A Splendour of
Succulents
&Cacti

T0287198

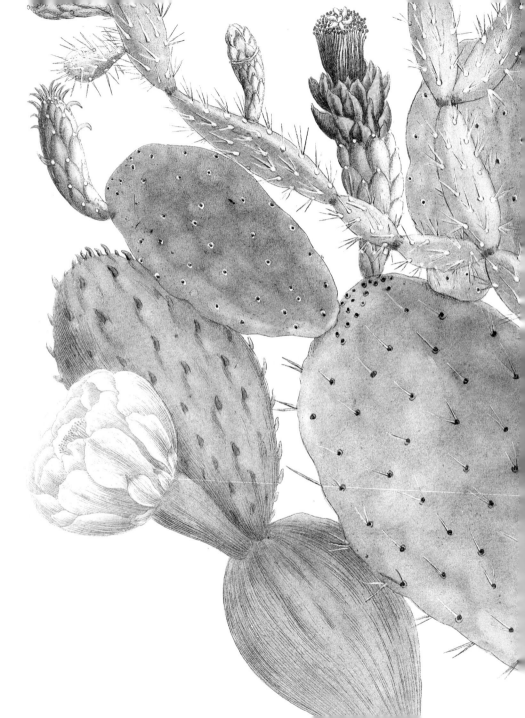

A Splendour of
Succulents
&Cacti

ILLUSTRATIONS FROM
AN EIGHTEENTH-CENTURY
BOTANICAL TREASURY

Caroline Ball

BODLEIAN
LIBRARY
PUBLISHING

First published in 2023 by the Bodleian Library
Broad Street, Oxford OX1 3BG
www.bodleianshop.co.uk

ISBN 978 1 85124 597 0

Text © Caroline Ball 2023
All images, unless specified, © Bodleian Library, University of Oxford, 2023

Publisher: Samuel Fanous
Managing Editor: Susie Foster
Editor: Janet Phillips
Picture Editor: Leanda Shrimpton
Cover design by Dot Little at the Bodleian Library
Designed and typeset by Lucy Morton of illuminati
in 12 on 16 Fournier
Printed and bound in China by C&C Offset Printing
Co., Ltd. on 157 gsm Chinese Golden Sun paper

British Library Catalogue in Publishing Data
A CIP record of this publication is available
from the British Library

Contents

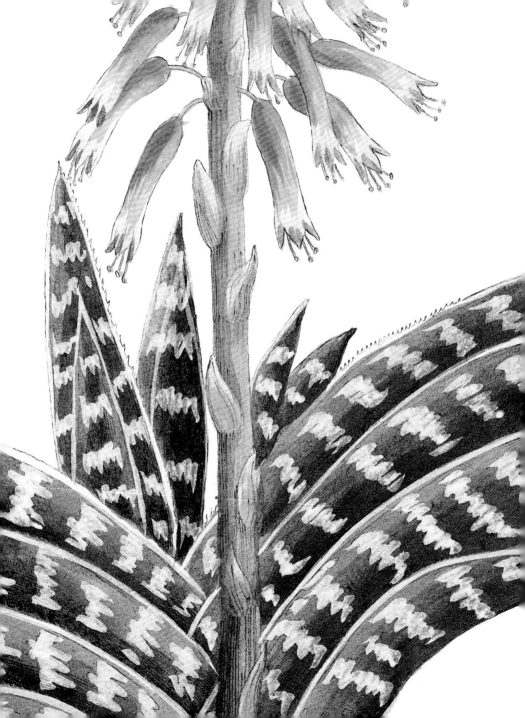

'It surprised me that what before was desert and gloomy should now bloom with the most beautiful flowers and verdure. My senses were gratified and refreshed by a thousand scents of delight, and a thousand sights of beauty.'

Mary Shelley, *Frankenstein* (1818)

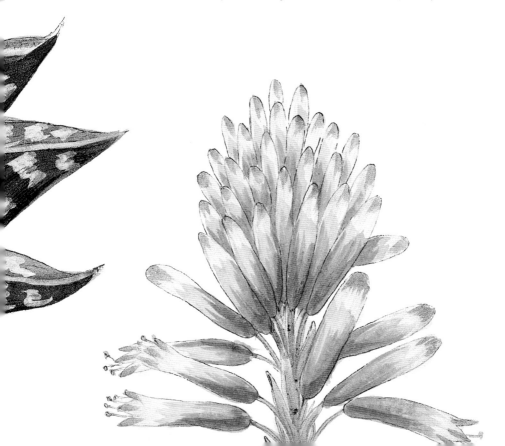

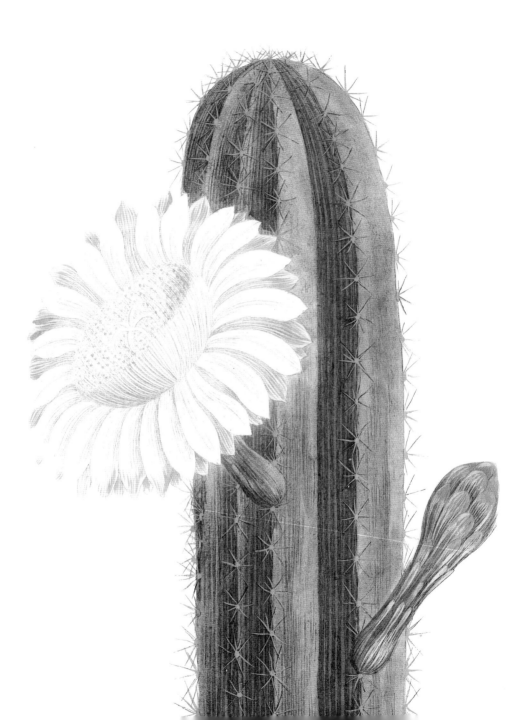

The dry life

How do you survive in a desert? If you're a human you equip yourself with plenty of water or dig deep wells; if you're a camel it's your specially shaped blood cells (no, not just your hump) that are key; and if you're a plant you either go into desiccated hibernation until the rains come or you evolve to hang on to whatever moisture comes your way. This is likely to give you a plump, juicy, *succulent* appearance.

What *is* a succulent?

Succulents come in myriad forms, from the towering and endearingly hairy Old Man of Mexico (*Cephalocereus senilis*) to the jewel-like mesembryanthemums that creep across the drylands of southern Africa. But they don't belong to any particular family or genus of plants. 'Succulent' is just a label for a fleshy plant, in the same way as 'variegated' denotes a patterned variation in leaf colour or 'climber' describes a plant that twines, twists or scrambles its way upwards.

Plants that have developed water storage facilities to survive in arid regions have done so in a number of different ways. For many the succulence is in their leaves, whether the neat rosettes of echeverias and sempervivums, the plump glossiness of the popular jade plant (*Crassula portulacea*) or the thick, spiky swords of aloes and agaves. Others have leaves that are reduced to mere spines and instead hold water in their stems, which are often vertically ribbed to allow for additional expansion. The columnar and barrel-shaped succulents, many of which are cacti, have taken this route. The saguaro cactus is about 85 per cent water, and it is estimated that a mature plant can hold something like 1,800 litres (400 gallons or more) of water. Then there are caudiciforms, for which the storage location is the trunk or caudex. The world's largest succulent is a caudiciform: the baobab tree (*Adansonia* spp.). Most baobabs are from Africa, especially Madagascar, but Australia has its own species, the boab (*A. gregorii*). As we shall see, succulents also have some cunning additional strategies to minimize water loss.

Unlike thorns, which are modified stems, the spines on a cactus such as this mammillaria (see page 115) are actually leaves. Rather like pine needles, they have evolved with a minimal surface area to reduce moisture loss.

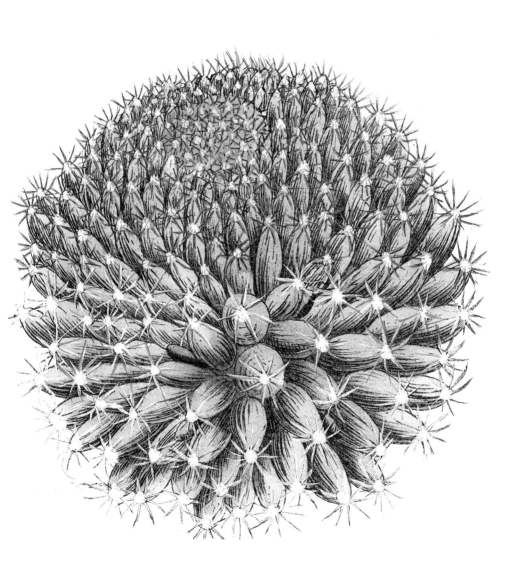

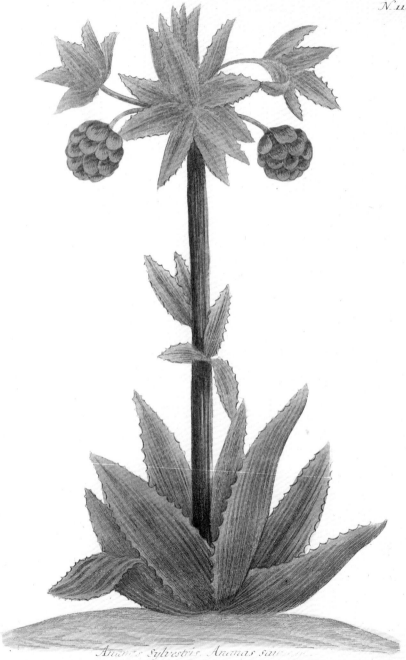

Ananas Sylvestris. Ananas sauvage.

Many plant genera, such as euphorbia and senecio, contain both succulent and non-succulent species. There are even a few succulent pelargoniums, living lives far removed from the cosy balcony troughs of a million Swiss chalets.

Succulents also occur in unexpected locations, not just hot deserts. Some grow by the seashore, such as samphire and glassworts (see page 118), and others inhabit the lush tropics. We might expect Brazilian forests to be the last place for succulents to have evolved, but many plants living high in the tree canopy have had to develop moisture-retaining abilities to supplement their needs. They include the familiar house plants Christmas/Thanksgiving/Easter cactus, whose 'leaves' are actually broad, flattened stems. At the other extreme, the dry rainshadow of the Canadian Rockies is home to the northernmost cacti in the world, including a type of miniature prickly pear, *Opuntia fragilis*.

'Succulent' is also used slightly differently by botanists and gardeners. To a botanist a pineapple, as a bromeliad, is a succulent, but we wouldn't expect to find it in a *horticulturalist*'s list of succulents. On the other hand, succulent enthusiasts and collectors are inclined to give yuccas honorary succulent status, although only a minority are considered so by botanists.

Columbus is believed to have brought back the first of these bromeliads to Europe, having observed the local Caribbean islanders eating the sweet fruit. It was named 'pine-apple' after its similarity in shape to a pine cone.

The Wonders of America stamp series featured the iconic saguaro cactus on the 39 cent stamp, issued in 2006. Saguaros grow slowly when young, but can reach 15 m (50 ft) or more.

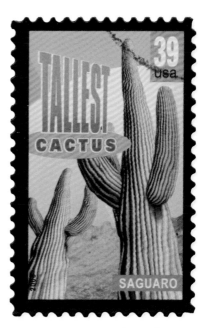

And where do cacti fit in? The expression 'cacti and succulents' is in such common usage that it suggests they are two related but different plant types. But cacti are just a family of succulents, *Cactaceae*, with specific characteristics. It's not enough to have leafless, fleshy stems or even, more surprisingly, to have spines – the defining element of a cactus is a little feature called an areole. Areoles are the growing points for a cactus's flowers, branches and spines. They often look like small pads of cotton wool (see, for example, pages 3 and 12) and may seem insignificant, but they are what make a cactus a cactus.

With one small exception,* cacti also all originated in the Americas. Ask a child to draw a picture of a desert, and alongside

* *Rhipsalis baccifera* may be native to Africa and Asia as well as South America. It is epiphytic, meaning it grows on the branches or trunks of other plants.

camels and palm trees you're likely to get some of those statuesque 'hands up or I shoot' cacti so familiar from cowboy films. This iconic giant is the saguaro cactus (*Carnegiea gigantea*), whose melon-scented flower is the state flower of Arizona. But while cacti populate large tracts of the harsh landscapes of the Americas you will not find a single freestanding cactus native to the Sahara, the Gobi, the Great Sandy Desert of Australia, or indeed any of the deserts outside the Americas.

A Brave New World

Early European explorers who ventured across the Atlantic brought back numerous plant novelties – potatoes, tomatoes and chocolate, among much else – but also the cactus.

These curious plants took on forms that Europeans had seldom encountered: towering 'trees' with no leaves and a few thickened side-stems that could barely be called branches; spiky globes the size of beer barrels with sides pleated like a concertina. Many had spines so fierce they prevented close inspection; others were so densely covered with fine hairs they earned nicknames such as Old Man Cactus and Teddy Bear Cholla.

Adventurous travellers observed the great variety of uses to which native Americans put these alien plants. They would have seen how strong, hooked spines were used for fishing, and how tall, unbranching cacti would be planted close together to create

an impenetrable palisade – unsurprisingly, one of the common names for *Stenocereus marginatus* is Mexican Fence Post. They would have learnt – often the hard way – that although cacti are swollen with water reserves, tapping into them for a drink can do more harm than good, but they came to relish the fruits (once divested of their spines). The exotically colourful dragon fruit, now a favourite in Asian restaurants, comes from a cactus (*Hylocereus* spp.) that originated in the tropical Americas.

Like coconuts in tropical Asia and the Pacific, agaves (which are succulents but not cacti) were an integral part of domestic life in the pre-Columbian Americas. The tough, fibrous leaves were processed into rope – sisal comes from an agave – and used for roofing (you can still see agave roof tiles in Mexico). The fleshy heart of the plant would be cooked and eaten, while its sap was fermented to produce *pulque*, an alcoholic drink to which much sacred ritual was attached. The Spanish incomers soon discovered that it could also be used to distil an even more potent liquor: mezcal. From this there developed in due course a refined version, tequila, distilled specifically from the blue agave.

A very different cactus was approached with caution, but not because of its spines – indeed, *Lophophora williamsii* appears to be just an unassuming ground-hugging little cushion. But for the indigenous inhabitants of what are now northern Mexico

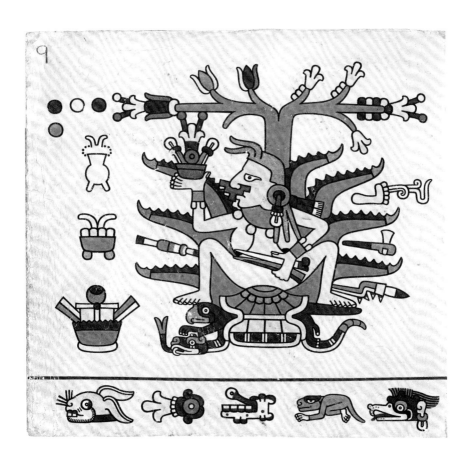

The first maguey (agave) was believed to have sprung from the body of Mayahuel, Aztec goddess of fertility. She is depicted here at the base of a flowering agave with a pot of *pulque* beside her. Cochineal provided the red colouring, still startlingly bright after more than 500 years.

and southern Texas, it was peyotl, or peyote, the source of the psychoactive drug mescaline. Sacred in particular to the Navajo, this was the drug with which Aldous Huxley first experimented in 1953 in a search for an expanded state of consciousness. What he wrote about his hallucinatory experiences triggered a whole psychedelic subculture in music and art and way of life.

Explorers (and exploiters) in the wake of Columbus were introduced to other cacti that were sources of hallucinogens and toxins with uses from hunting to medicine to spiritual visions, but they also found that one cactus harboured a treasure worth a fortune back in Europe.

The nopal – which we know better as opuntia or prickly pear (like the one on page 12) – is the host plant for a small bug, *Dactylopius coccus*. For centuries it had been harvested in Peru and Mexico, where it was processed into a red colourant used both for dyeing and as an ink. To the Aztecs it was *nocheztli* but the Spanish called it *cochinillo* – cochineal. The colour it yielded was so rich and bright that it outclassed the reds from lead, kermes, madder, cinnabar and other sources to which Europeans had hitherto had access. Dyers, clothiers and tapestry-weavers clamoured for this new pigment as soon as it reached Europe in the 1520s. Artists, too, revelled in this new addition to their palettes. Sadly, when used as a paint its richness of colour has not proved as long-lasting, and works of artists from Rubens to Turner to Van Gogh have lost

much of the original verve that cochineal gave their renditions of scarlet cloaks, dresses and sunsets.

Within fifty years of the first shipment, the value of cochineal had outstripped every commodity in transatlantic trade except silver and gold. The Spanish fiercely guarded their monopoly until the late eighteenth century, although several attempts were made to break it. One daring plan in 1777, by a Monsieur Thiéry de Menonville, almost came off. In an adventure full of derring-do and disguises, he smuggled out a cache of the live insects and established them on a prickly pear plantation in Haiti. Unfortunately (for France), however, he died soon after and his illicit bugs soon followed suit from neglect.

Opuntias – without their valuable little parasites – were one of the first cacti to be introduced to Europe and they soon made themselves at home anywhere that suited them. They are now so much a part of the rocky hillsides and roadside scrub in southern Spain that they are frequently believed to be native, while in Australia they became a menace on a huge scale. A decade after Thiéry de Menonville's failed enterprise, opuntias were introduced to the fledgling Sydney settlement with the same intention: to establish a cochineal dye industry. (The British soldiers got their name of Redcoats from the scarlet of their uniforms, which, in the upper ranks at least, were made from cochineal-dyed cloth.) In a classic case of unintended consequences, the cochineals

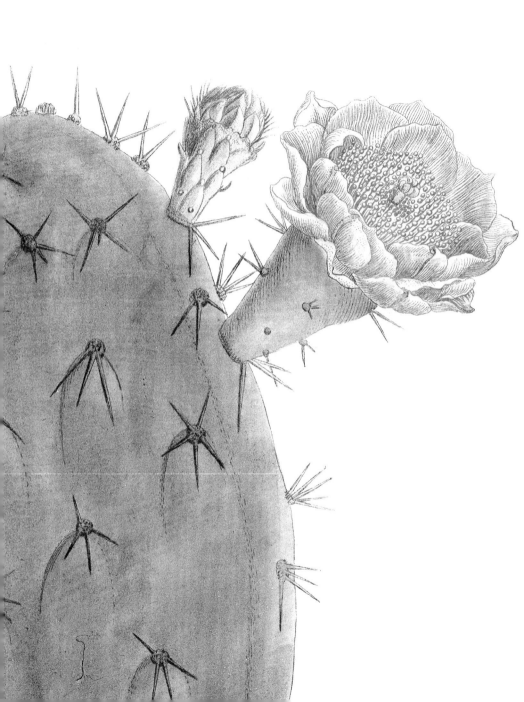

died out but the prickly pears flourished and only a century later Australians were waging war on this rampaging plant. By the 1920s it was estimated prickly pears had taken over and rendered unusable more than 24 million ha (60 million acres) of Queensland and New South Wales; that's about the same surface area as the whole of the UK. Rescue came in the form of a moth whose larvae feed on opuntias at a fantastic rate, but prickly pears are still classified as a 'weed of national significance'. However, it may be that this opportunistic plant is on the edge of an entirely new career: instead of being a vehicle for supplying cloth dyes, it is beginning to take to the catwalk itself as ventures in processing opuntias into vegan leather are showing commercial promise.

From the Sonora to the sitting room

Away from their natural habitats, succulents have made a very successful transition into our homes, and it's not hard to see why. Many of them have a clean-lined look that suits a modern urban decor, and they thrive in a dry, centrally heated atmosphere that can put stresses on house plants that originate from more humid environments. Indoor plants of any sort provide a little but often much-needed connection with nature, particularly in a home with no outside space, and succulents can be especially rewarding, as they mostly come without complicated potting, pruning or propagating requirements to bamboozle novices. They are

undemanding and – dare I say it – even thrive on neglect. The Victorian poet Louisa Campbell wrote a collection of poems on what plants might teach us about life. In one she asks her *Cactus grandiflora* [*sic*] why, when she nurtures it so carefully, 'yet never to flower you try'. It replies:

> When broken and bruised by the heedless foot,
> Of the beasts as they wildly roam;
> More firmly I grasped the earth with my root,
> In my far off wilderness home,
> And the flowers I bore were bright to see.

The lesson to draw from this, she concludes, is that what doesn't kill you makes you stronger. This is not to advocate trampling your succulents underfoot, of course!

The flowers are one of the unexpected beauties of a succulent, often surprising with their intense colour or grand scale. One of the most spectacular in terms of size is an agave (*A. americana*, see page 30), called the century plant because it was believed it waited a hundred years to throw up its dramatic flower stem. In fact they can bloom after 'only' a decade or so, but it is a sight not to be missed: the flower stem can shoot up to around 8 m (25 ft) and some have been known to top 12 m (40 ft). Such an event is bittersweet, as the whole plant then dies, albeit usually leaving behind a posse of next-generation plantlets.

Agaves are not the only succulents that know how to play on anticipation. Several flower only fleetingly, just for a few hours, and some, such as the night-flowering cereus (see page 113), add to the drama by blooming only under cover of darkness. This quirk has evolved not to add an air of mystery, but to attract nocturnal pollinators; it also helps water conservation, as opening flowers during the heat of the day would result in greater moisture loss.

In addition to night flowering, many succulents have evolved a specialized form of 'night breathing'. Plants exhale oxygen, a by-product of the process of photosynthesis, by which they convert light, water and carbon dioxide into vital energy. Usually, they open the stomata (pores) in their leaves during the day to 'breathe', but this inevitably also allows moisture from within the plant to escape. Most succulents overcome this obstacle by keeping their stomata closed during the day, only opening them to release oxygen at night. This adaptation is called CAM (crassulacean acid metabolism), after the first group of plants, *Crassulaceae*, in which it was observed; it is often described, graphically if not quite accurately, as plants 'holding their breath'. This release of oxygen overnight has led to succulents sometimes being recommended as super-purifiers of air in our homes, but while plants improve the quality of our indoor environment in many ways, it would take far more cacti than any living room or

bedroom could accommodate to make an appreciable difference to the oxygen levels.

However, it has been discovered that many other plants, not just succulents, adopt the CAM mechanism, sometimes only temporarily when conditions demand, and this may be of great interest as our climate changes. Succulents and other xerophytes (plants adapted to arid conditions) are attracting the attention of agronomists and botanists looking to the future. As water becomes an increasingly precious resource, plants that can survive drought or flourish in saline conditions (such as glassworts; see page 118) are being studied and trialled for their commercial potential and ability to survive where other plants cannot.

Succulentomania

New succulents are being introduced every year. Some are discoveries of previously unrecorded species, but many are hybrids that have been bred with the ever-increasing numbers of fans and collectors in mind. Plant of the Year at the 2022 Chelsea Flower Show was a colourful variety of x *Semponium*, a ground-breaking cross between a sempervivum and an aeonium (see page 121). The downside of their popularity is a huge increase in cactus rustling. Almost a third of cacti species in the wild are designated as under threat, either from habitat loss or from illegal collection in the wild.

Succulentomania may seem like a new, modern trend, but the first time cacti caught the public's imagination and became collectable items was back in the sixteenth century. Christopher Columbus is traditionally credited with introducing the first cacti to Europe, initially 'echinomelocactus' (see page 115) and 'Indian figs' – that is, opuntias or prickly pears. These exciting curiosities and their cousins began to feature in exotic plant collections but also in art. A melocactus, as well as a large cereus, for example, contribute to the vivid scenes that make up the *Teintures des Indes* tapestries woven at the pre-eminent Gobelins works in the 1690s. (The only surviving set now hangs in the Grand Masters' Palace in Valetta, Malta.)

For collectors, providing these desert treasures with the habitat they required was a great challenge, but one successfully overcome by those with the money and the vision. Despite – or perhaps because of – the difficulties of raising desert plants in a cool, damp climate, some of the most ambitious collections were in the Netherlands, Germany and Scandinavia. When William of Orange and Mary II took up the throne of England in 1688, Queen Mary's 'tender exoticks', including many succulents, were housed in specially constructed early glasshouses. Her collection in due course formed the basis of the world-famous Kew Gardens. A century later Emperor Franz Joseph II of Austria was presented with a very odd-looking plant dug up from the South African

veldt. It was identified as a caudiciform succulent (see page 2), *Fockea crispa*. Astonishingly, 'Die Alte Dame von Schönbrunn' as she is known, still survives more than 200 years on – more a thing of curiosity than of beauty – and can be visited at the Wüstenhaus or desert house in the grounds of Schönbrunn, the spectacular former imperial palace in Vienna.

Naturally, succulents in their many forms aroused the curiosity of apothecaries and 'natural philosophers', and the influx of plants from the New World was instrumental in hugely expanding the content of herbals. Leonhart Fuchs's *Great Herbal* of 1542 had illustrated some 500 plants; by the time John Ray came to compile his *Historia Plantarum* some 150 years later he included some 20,000 – not all New World introductions, to be sure, but an indication of the explosion of interest in what plants could do for us.

Caught up in this enthusiasm was a German apothecary, Johann Wilhelm Weinmann (1683–1741). As a young man he had settled in the ancient Bavarian town of Regensburg, on the banks

Johann Wilhelm Weinmann at the age of 54, from the frontispiece to Volume 1 of the *Phytanthoza Iconographia*. Mezzotint by J.J. Haid, one of the leading engravers of Weinmann's great work.

OVERLEAF The historic Mohrenapotheke (Moorish Pharmacy) in central Regensburg, which Weinmann bought in 1712 and restored to a successful business. Weinmann himself is depicted under the fountain. Watercolour on parchment, 1717.

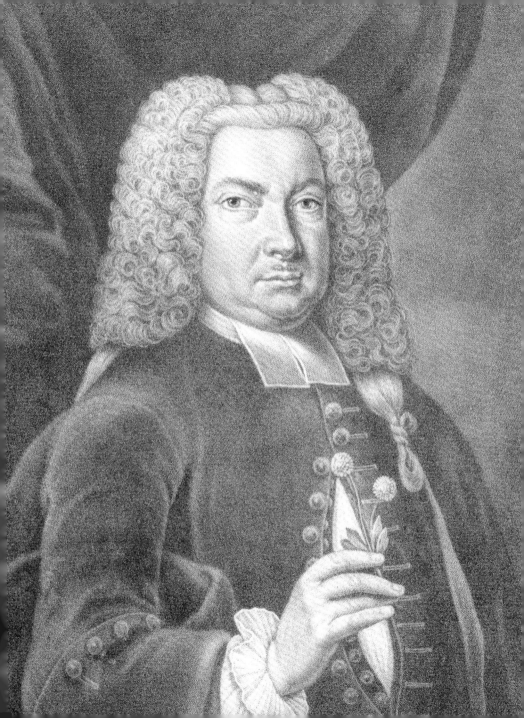

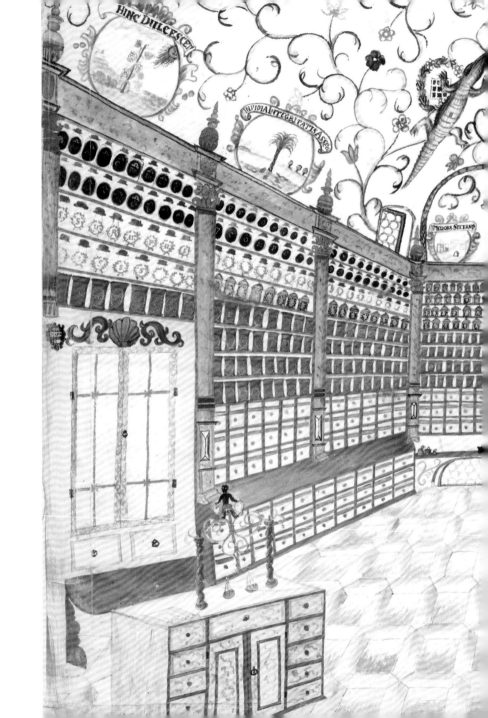

HINC DULCESCEN

INVIDIA INTEGRITATIS ASSE

MELIORA SECKANO

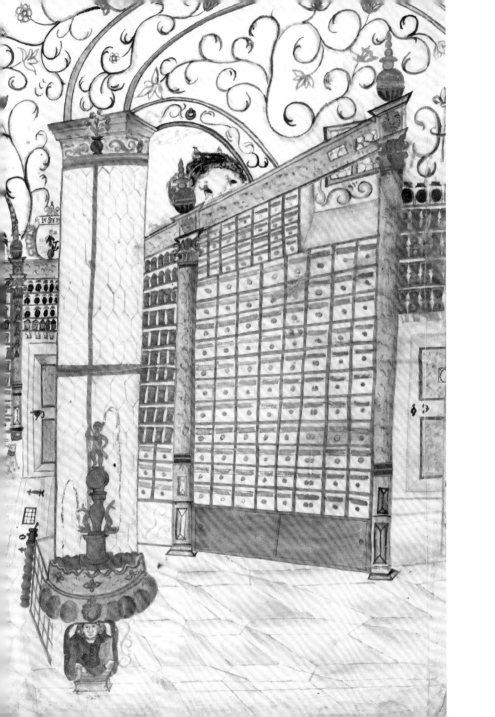

of the Danube, where he bought the historic but neglected Mohrenapotheke. He appears to have been commercially astute, restoring the Apotheke's fortunes, and by the time he was 40 the success of his business had brought him standing in the community and allowed him the time and money to indulge his passion for studying plants. As well as cataloguing the pharmaceutical contents of his now thriving shop, he became an avid plant collector, establishing a botanical garden. He also contributed several essays on plants to *Breslauische Sammlungen*, the *New Scientist* or *Nature* of his day. One of these was devoted to aloes, and his special interest in them came to be reflected in an ambitious project that would take him the rest of his life.

Taking the botanical garden he had created as his starting point, Weinmann envisaged an authoritative and detailed account of plants and their uses; it would not only include all the plants recorded in the known world but would illustrate them using modern techniques that would give realistic colour and fine detail unavailable to previous generations. All the strikingly beautiful botanical images in this book come from these now rare and precious volumes, to which Weinmann ascribed a tongue-twister of a title: *Phytanthoza Iconographia*. The next section provides a brief background to the *Iconographia*'s place in history and how it was made.

The *Phytanthoza Iconographia*

Through the Middle Ages and beyond, the traditional form
of plant reference book was a herbal – essentially a practical
guide to the uses of plants, especially medicinal. The illustra-
tions, which would have been printed from woodblocks, aimed
to be an accurate record of what each plant looked like, so that
they could be confidently identified. One of the best known to
us is Gerard's *Herball*. In his first edition (1597) John Gerard
recorded more than 1,000 plants and more were added to later
editions.

It was quite common for the same woodblocks to be
used and reused, and for copies of copies to be made, so
that over time detail became blurred, mistakes crept in and
illustrations became less useful, with the obvious dangers that
misidentification might entail. Then along came Leonhart
Fuchs (1501–1566). Fuchs, after whom the fuchsia is named,
has been called one of the fathers of botany, and he led the way
in insisting upon accurate descriptions and artistic renditions
of plants. Through his influence botanical illustrations were
taken to new heights of precision, often including details of
distinctive parts of a plant and depicting the same species in
different seasons.

Herbals classed plants according to their observable char-
acteristics and their uses, and when the early botanic gardens

were founded, first in Italy and then throughout Europe, they were set out in the same manner as a herbal, with beds corresponding to the uses to which plants were put: the living embodiment of what a student might see on the page.

A different but related form of plant book was the florilegium. Florilegia, although also intended as botanical records, included ornamental plants and placed emphasis on beauty of presentation rather than on practical information. A florilegium could relate to a specific plant family or the flora of a region, such as Redouté's renowned *Les Roses* (1817–24) and the early-nineteenth-century *Flora Graeca* compiled by John Sibthorp and Ferdinand Bauer. It could even immortalize a specific garden: Basilius Besler's precious *Hortus Eystettensis* (1613) recorded the floral year of the palace gardens of the prince-bishops of Eichstätt. The practice continues into our time, exemplified by the *Highgrove Florilegium* commissioned by King Charles when he was Prince of Wales.

Weinmann's master work rather straddles the two forms: a florilegium with the botanical information of a herbal, or a herbal with the aesthetic beauty of a florilegium. The grandiloquent title by which it is known, a 'Latinization' coined by Weinmann presumably to convey the work's importance, is actually only the first two words of the long and exaltant title that in full proclaimed, in Latin and German:

ICONOGRAPHY OF
PLANTS AND FLOWERS TO THE LIFE,
or
Conspectus
of some thousands of
Plants, Trees, Shrubs, Flowers, Fruits, Fungi, etc.,
both Native and Foreign,
collected from the four parts of the world
over a long series of years and with untiring zeal
by
JOHANN WILHELM WEINMANN,
Adviser to the Regensburg Court of Justice and Senior Apothecary,
which,
engraved most splendidly on copper,
are printed and portrayed with living colours and images, rivalling nature,
by an art both long desired and recently discovered,
through
BARTHOLOMÄUS SEUTER,
JOHANN ELIAS RIDINGER AND
JOHANN JAKOB HAID
Painters and Copper-engravers of Augsburg,
of which
the Denominations, Characters, Genera, Species and Descriptions
are candidly laid out in the Latin and German language
from the best Authors, both ancient and modern,
in Alphabetical order and series,
with the most tested Medical, Pharmaceutical,
Surgical and Household usage,
by
D. JOHANN GEORG NICOLAUS DIETRICHS,
Counsellor of his Holy, Imperial and Royal Catholic Majesty,
the most Serene Prince of Furstenberg-Stühlingen,
[and] Doctor-in-ordinary and Physician of the Republic of Regensburg.

PHYTANTHOZA
ICONOGRAPHIA,
Sive

 onſpectus

Aliquot millium,

tam Indigenarum quam Exoticarum, ex quatuor mundi
partibus, longâ annorum ſerie indefeſſoque ſtudio,

à

JOANNE GUILIELMO WEINMANNO,

Dicaſterii Ratisbonenſis Aſſeſſore & Pharmacopola Seniore
collectarum

Plantarum, Arborum, Fruticum, Florum
Fructuum, Fungorum. &c.

Quæ

Nitidiſſime æri inciſæ & ſimul diu deſiderata ac recens inventâ arte, vivis colori-
bus & iconibus, naturæ æmulis, excuſæ & repræſentatæ

Per

BARTHOLOMÆUM SEUTERUM, JOANNEM ELIAM RI-
DINGERUM ET JOANNEM JACOBUM HAIDIUM
Pictores & Chalcographos Auguſtanos.

Quorum

Denominationes, Characteres, Genera, Species & Deſcriptiones
ex optimis, tam priſcis quam neotericis Auctoribus, ordine ac ſerie Alphabe-
tica, cum probatiſſimo uſu Medico, Pharmaceutico, Chirurgico ac Oeco-
nomico, latino & Germanico idiomate
ſincere explicantur

à

D. JOANNE GEORGIO NICOLAO DIETERICO,
Sacræ Cæſareæ ac Regiæ Catholicæ Majeſt. Conſiliario, Sereniſſimi
Principis de Furſtenberg - Stülingen Medico ordinario ac Reipublicæ
Ratisbonenſis Phyſico.

Vol. I. A. B.

Apud prænominatos Pict. & Chalcogr. Auguſtæ venum proſtat, quorum
ſumtibus imprimebatur

RATISBONÆ
per Hieronymum Lenzium, M DCC XXXVII.

The first complete volume was published in 1737 (small sections had been issued a couple of years earlier) and grew over succeeding years to four immense volumes (sometimes bound in eight volumes, with the text separated from the illustrations). The entire work, containing 1,025 plates of illustrations depicting more than 3,500 different plants, was not completed until 1744, three years after Weinmann himself died. The *Iconographia* describes and illustrates everything from apples to zinnias – or, because he ordered them alphabetically by the Latin name that prevailed at the time, from *Abies* (firs) to *Zinziber* (gingers) – and his legacy gives us an unparalleled view of the ornamental and useful plants that were known to botanists and gardeners in the early eighteenth century.

It also provides a fascinating insight into the confusion surrounding some plants, especially those that came from far-off lands where few Europeans ventured. Gutta gummi or gutta gamandra, for example, was a glutinous yellow resin over which there was much speculation. Artists, who used it before its medical properties were explored, knew it as the yellow pigment called (as it was believed to come from Cambodia) gamboge. Apothecaries then prescribed it for dropsy, ague and 'arthritical

Title page (Latin version) of the *Phytanthoza Iconographia*.

paines' including 'hip-gout' (sciatica), liver-related problems (perhaps guided by its yellow colour) and, of course, the popular purging. Its source, however, was shrouded in mystery. Sap from a succulent was a popular guess, and in *A treatise of the nature and qualities of such simples as are most frequently used in medicines* (1652), Robert Pemell confessed:

> What it is made of none hath yet certainly determined; some conceive it to be the juice of Spurge … others judge it to be made of Scammonie and Tithymal: others judge it to be made of Rubarbe; others of Euphorbium; others think it to be made of one kind of Aloes.

Several succulents to choose from there. Interestingly, the *Iconographia* shows it as a fiercely spiked, fleshy, vine-like climber, but the text says otherwise. After putting forward the same suggestions as Pemell, Weinmann says he consulted the Indian botanical treatise *Hortus Malabaricus* and concluded (rightly) that it was resin tapped from a substantial tree known as Coddampulli (*Garcinia morella*).

Gutta gamandra, as depicted in the *Iconographia*. It would appear to have been modelled on a very similar drawing in *Traité universel des drogues simples* (1698) by the French apothecary Nicolas Lémery, whose books were widely read and translated.

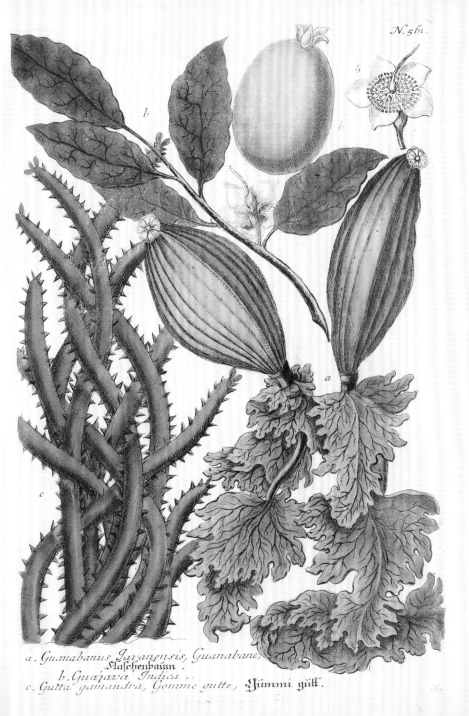

a. *Guanabanus Javanensis, Guanabane,*
 Flaschenbaum.
 b. *Guajava Indica* ..
c. *Gutta gamandra, Gomme gutte,* Gummi gütt.

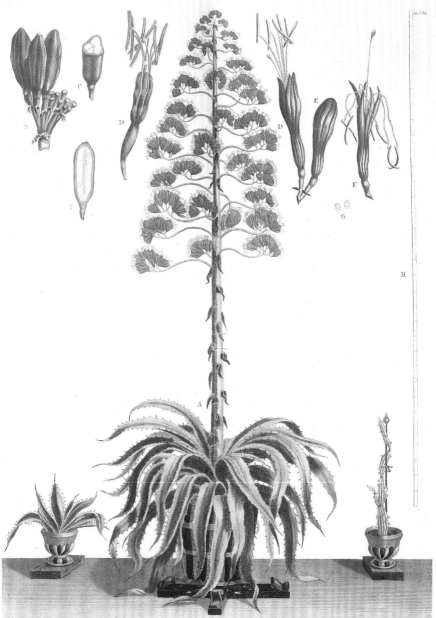

A. Aloe Americana folio Mucronato, geblühet zu Regenspurg Anno 1735, hatte 7672. Blühten, der Stam des Stengels hat unten her 8. Zoll, die Blätter
sein 5. bis 6. Schuh lang, besihe Tit. Herrn Iohann Wilhelm Weinmanns Phytanthoza iconographia pro 33. und die 42. Tab. a und b. die Saamen Hül-
sen oder Früchten in ihrer natürlichen größe. C. zerschnittene Hülsen. D. völlig geöfnete Blühte. E. eine noch verschloßene Blume. F. wie die Blühte wider allge-
mach abstehet. G. der Saame. H. verjüngter Maaß Stab, welcher andeutet, daß die Aloe 32. Werck Schuh von der Wurzel bis an den Gipfel hoch gewesen.

Probably the most startling – and now one of the rarest – images created for the *Iconographia* was one very personal to Weinmann. It was of an aloe, now recognized as *Agave americana*. For many of the less accessible plants, the artists had to rely on secondary sources, prints from other herbals or even travellers' descriptions, but this specimen was painted from life, for it was in Weinmann's own collection. Most astonishing, however, is that it is shown in flower. For this is the century plant which, as we have seen, takes decades to reach flowering stage and blooms only once before dying. Unlike the simple labelling of other plants, this is captioned only in German and tells us that it flowered in Regensburg in 1735, when it had 7,872 blossoms. What an extraordinary sight this must have presented to eighteenth-century Bavarians. The details of flowers and seed pods are drawn full size, and to the right of the page is a scale indicating the full height of the flower stem. It is shown to have reached 32 *Werck Schuh* – this can be taken to equate to about 32 ft, or not far off 10 metres!

Because the image of this enormous plant was itself over-sized, it was included in only some copies of the *Iconographia*, and is now exceedingly rare.

No doubt to convey its stature and rarity, the image of Weinmann's own *Aloe Americana* (Century Plant) was printed on an extra-large sheet that folded down in between the *Iconographia*'s covers.

But what of the other images? Who painted them all and how were they produced?

The apothecary and the young artist

To describe the characteristics of each plant and to list their practical uses, Weinmann looked to a fellow Regensburg worthy, Dr J.G.N. Dieterichs. (Dr Dieterichs died in 1737 but his work was continued by his son Ludwig Michael, then by Ambrosius Karl Bieler.) The text, in Latin and German, is detailed and comprehensive, but it is for its illustrations that the *Iconographia* is still so highly treasured today. In his first artist, Weinmann was extraordinarily lucky, although he did not appreciate his good fortune.

In 1728, as he was embarking on this new enterprise, Weinmann encountered a young gardener who was travelling with his brother to Vienna. They had come from Durlach, some 200 miles (300 km) to the west, and were working their way down the Danube when they alighted at Regensburg. Georg Dionysius Ehret had been encouraged to draw as a child, and his talent as a botanical draughtsman had been developed in his years as an apprentice gardener. In the employ of the Margrave

Mezzotint portrait of Georg Dionysius Ehret, aged around 40, by J.J. Haid.

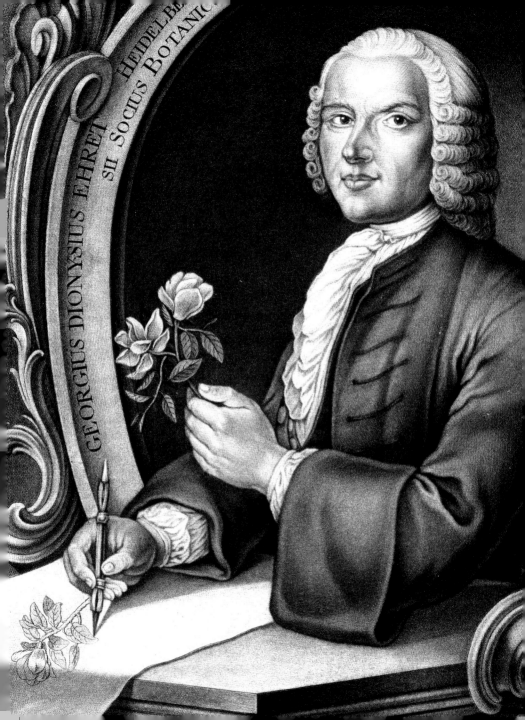

GEORGIUS DIONYSIUS EHRET HEIDELBE
sii Socius Botanic

of Baden Durlach, he had honed his artistic as well as his horticultural skills. Soon after Ehret's arrival in Regensburg he was introduced to Weinmann, who showed him his collection of botanical illustrations and talked about his plans for a complete illustrated herbal. Ehret was only 20 years old, but on inspecting the paintings Weinmann had amassed he had the confidence in his own talent to say, as Weinmann later recalled, *Das solte ich mahlen, es solte weit besser werden* – 'I should paint it, it would be better.'

Georg Ehret's name is today uttered with awe by botanical artists and art historians, and he is considered one of the very finest illustrators from a golden age of botanical art. But at the time of his first encounter with Johann Weinmann he was young, unknown and poor, and welcomed the opportunity to work on what promised to be a prodigious, and probably prestigious, publication. They agreed a fee of 50 thaler on completion of a thousand illustrations in twelve months. Ehret was glad of the work, and no doubt the board and lodging Weinmann offered, but it became apparent that neither the payment nor the timescale was sufficient. At the end of his year's work, Ehret had completed 500 illustrations but needed more time and more payment. (It's not really possible to judge how paltry the fee was, though it has been suggested it equated approximately with the pay of a barber at the time. However, to finish a thousand highly detailed,

accurate illustrations in a year would have required the artist to churn them out at a rate of about three a day, which clearly had been an unrealistic expectation.) Neither could agree on terms, and they parted less than amicably.

Ehret found work with other, less parsimonious, backers around Europe, and a few years later in the Dutch town of Leiden he met an academic young Swede his own age who was at work on developing a hierarchical system of classification for the natural world. This was the great botanist Carl Linné, better known to the world as Linnaeus. Ehret provided Linnaeus with drawings for his *Systema Naturae* (1735), learning much in the process about the structure and relationships of plants. The two men also worked together on one of the great florilegia, the Dutch *Hortus Cliffortianus*, though by the time this was published, in 1738, Ehret had settled in England. Here he painted, taught the aristocracy and built a towering reputation through his art. Among many other commissions he supplied illustrations for books by Philip Miller, the long-standing and highly esteemed curator of Chelsea Physic Garden; he also married Miller's sister-in-law. In 1750 he was appointed superintendent of Oxford Botanic Garden, a position of high prestige, but was sacked less than a year later when he refused to swear an oath to the Professor of Botany. His style of botanical painting became known – is still known – as the Linnaean style.

The old and the new

After his ill-tempered break with Ehret, Weinmann had to find other artists to complete his great work. The later artists were not necessarily as adept or as botanically knowledgeable as Ehret, though the talent of Fräulein N. Asamin was particularly admired, but the overall impact and the sheer scale of the work cannot fail to impress. It also benefited from an innovative printing method used to reproduce the subtle colouring of the original watercolours.

Nowadays, we take photographic colour reproduction for granted, but in the early 1700s the standard method of reproducing artwork for print was to recreate the images as engravings on metal plates. These could produce finer detail and shading than was possible from woodcuts, but were generally limited to black-and-white images that could then be hand-coloured. However, with the coming of mezzotint, a method of engraving that rendered actual gradations of tone, there also evolved the idea of printing in colour. An image would be printed using three plates, each loaded with one of the primary colours (blue, red, yellow); later the process was refined when a fourth (black) plate was added. Essentially, this is the basis of modern four-colour printing.

A different approach was to mix the inks and apply the colours to the engraved plate before it was put through the press in a

single pass; in effect, to paint
the engraving. This was
known as printing *à la poupée*,
because in place of brushes
the colour was applied to the
engraved plate with a small
rag twisted to look like a tiny
rag doll.

Weinmann's *Phytanthoʒa*
Iconographia was one of the
earliest (sometimes claimed
to be the first) botanical work to
use this colour mezzotint method.
It was certainly the most ambitious
publication in its field. The images
actually used a mixture of methods,
drawing on the advantages of mezzotint
and hand-coloured etchings to render
most effectively naturalistic colouring

Weinmann's Aloe Guineensis, with
'roots like knees', has long been a
popular house plant, commonly
called African bowstring hemp or,
less kindly, mother-in-law's tongue.

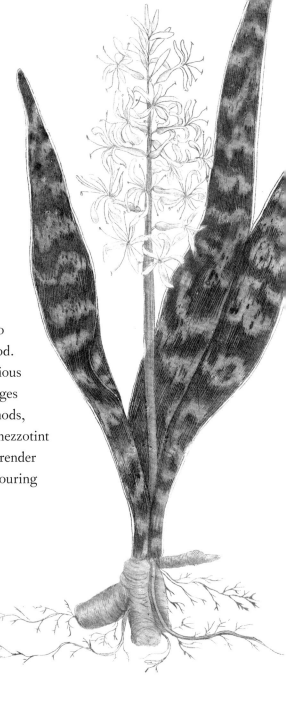

without losing fine detail. The very best engravers of the time were engaged – in particular Bartholomaüs Seuter. It is telling that although none of the original artists signed their work or were individually acknowledged, the engraver's skill was highly regarded, and on his title page Weinmann recognized the work of Seuter and his fellow engravers, Haid and Ridinger; many of the plates are initialled *S* or *H*, presumed to indicate the engraver responsible.

While Weinmann's books were forward-looking in the method of colour printing, they were slightly old-fashioned in another sense. If Weinmann had been compiling his masterwork just a couple of decades later, the Latin captions that identify the plants on each plate would have read quite differently. With the adoption of Linnaeus's system, plant-naming was considerably simplified and streamlined, reducing every name to just two parts: genus and species. This binomial system is, with adjustments, what we still use today.

This rationalization and streamlining obviously had much to recommend it, but a certain picturesqueness of language has been lost. What Weinmann and his contemporaries knew, for example, as *Aloe Guineensis radice geniculata foliis è viridi et atro undulatim variegatis* translates as 'Aloe from Guinea with knotted roots [literally roots like knees], and leaves variegated in green and black waves'. The modern name, *Sansevieria* (or *Dracaena*)

hyacinthoides, focuses not on the patterned leaves or the rhizomatous roots but the fragrant and hyacinth-like flower.

Linnaeus's new classification system was timely, because the number and variety of plants that needed to be identified were increasing fast. As we have seen, pushing the boundaries of the known world was swelling the numbers of plant introductions, and botany and the natural sciences as a whole were providing endless material for close observation, contemplation and intellectual discussion among the educated.

Pharmacology has moved on immeasurably, and Weinmann's intention – to provide an encyclopedic guide to plants from the four corners of the world – has been superseded as botanical discoveries and medical practice have advanced. Many of our most popular succulents had yet to be discovered in his day – the prolific and pretty echeverias, for example, were not seen in Europe until the early nineteenth century – but we can be amazed at just how many and wide-ranging were the succulents that not only were known in Europe nearly 300 years ago but actually flourished and flowered.

THE PLATES The marvellous array of succulents on the following pages are as they appear in the *Iconographia*, together with their original *N* plate numbers. For identification and more specific information, see pages 110–23.

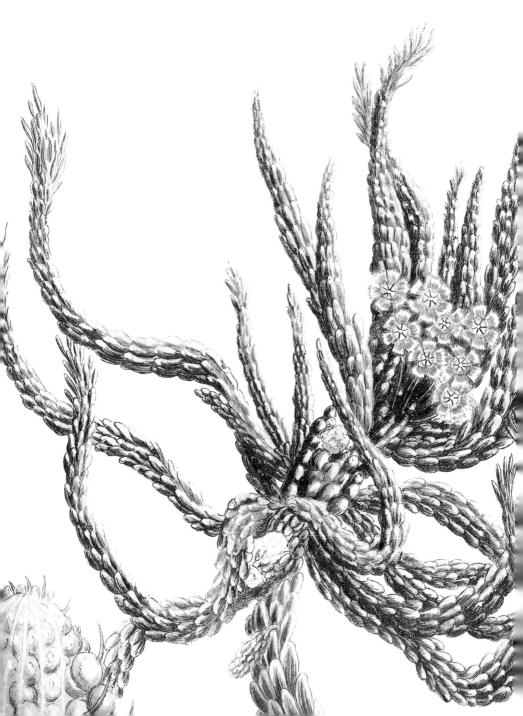

Succulents & cacti

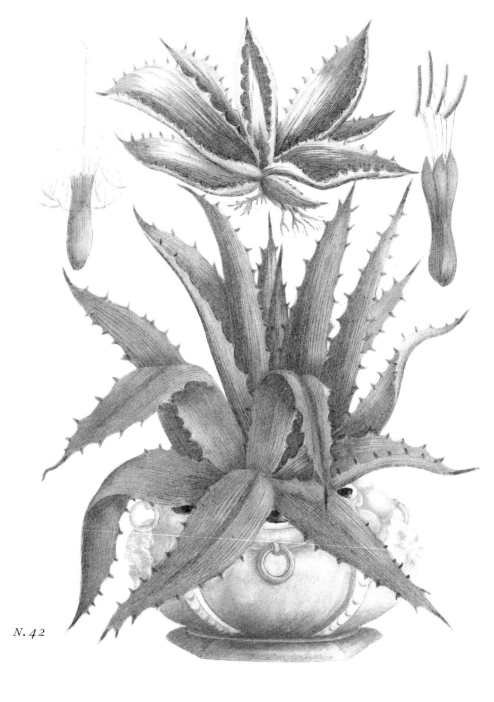

N.42

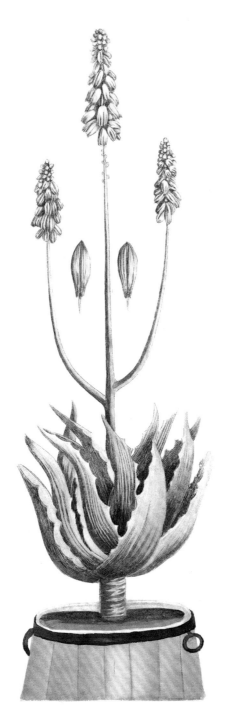

N. 43

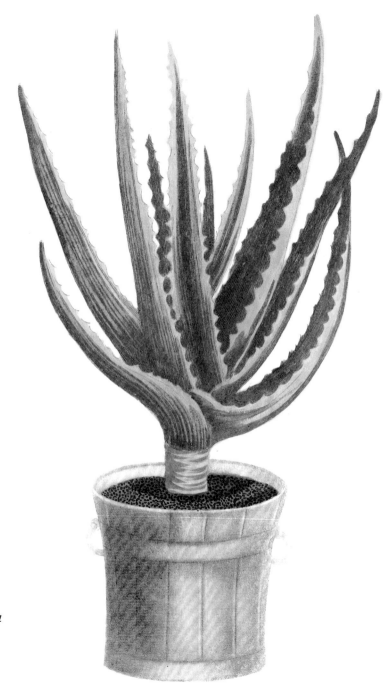

N.44

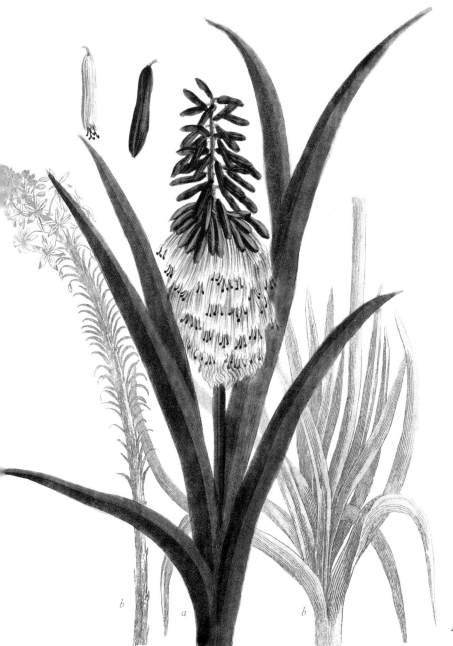

b a b

N. 45

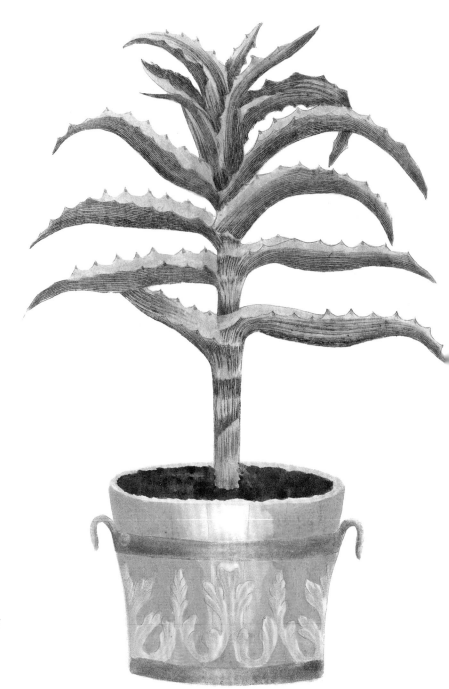

N. 46

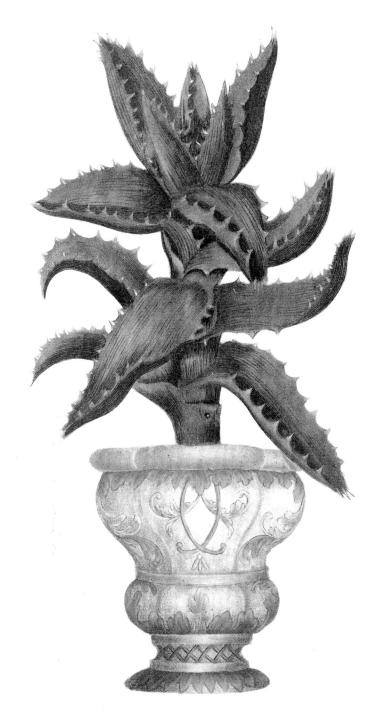

N. 47

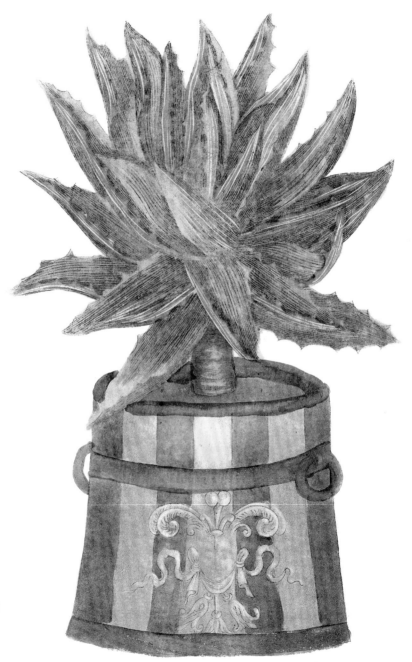

N. 48

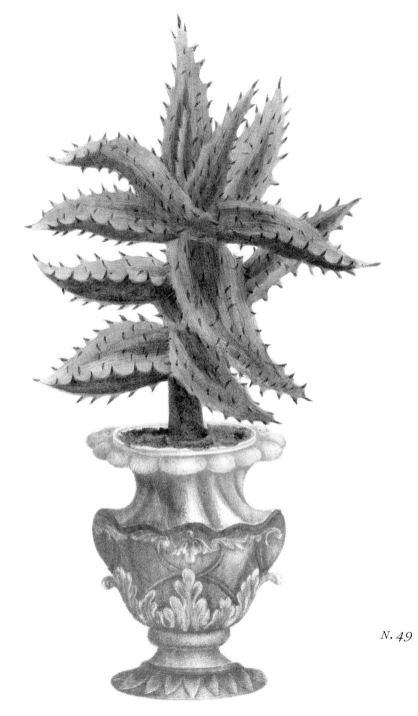

N. 49

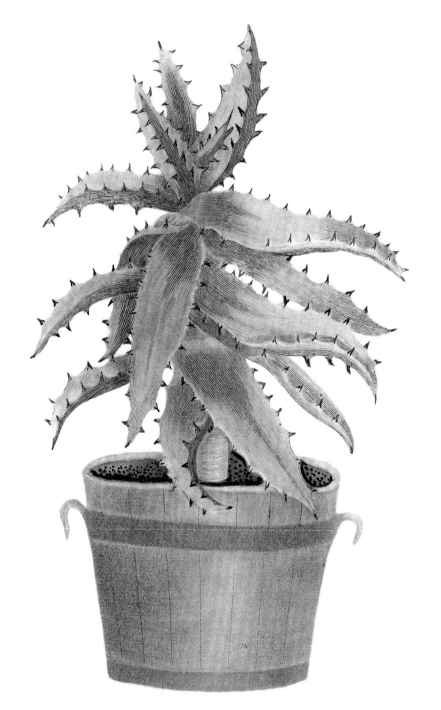

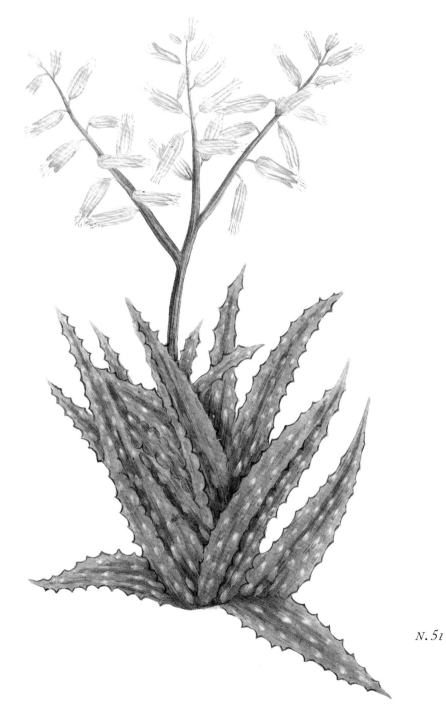

N. 51

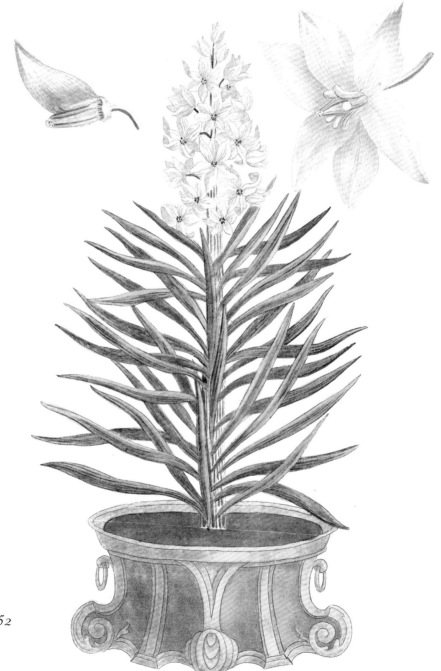

N.52

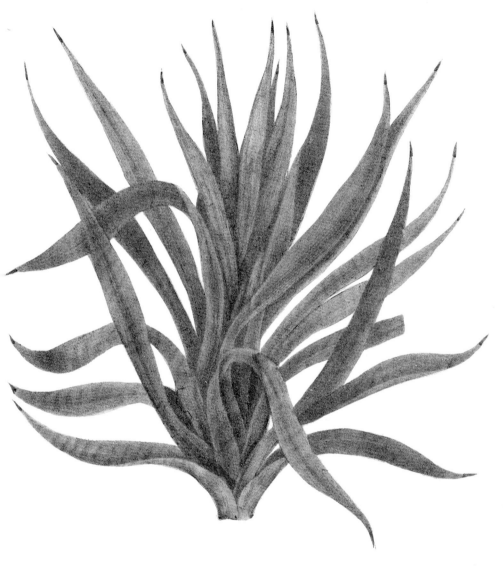

N. 53

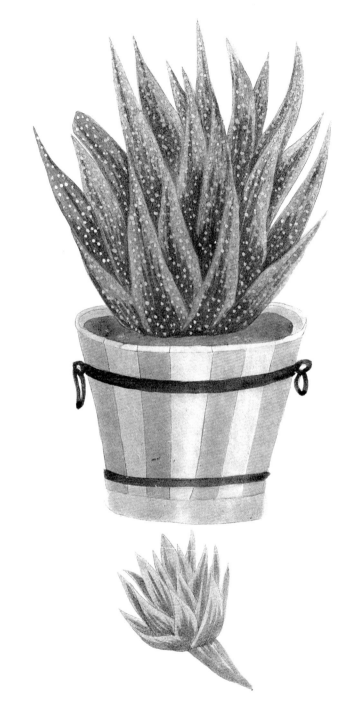

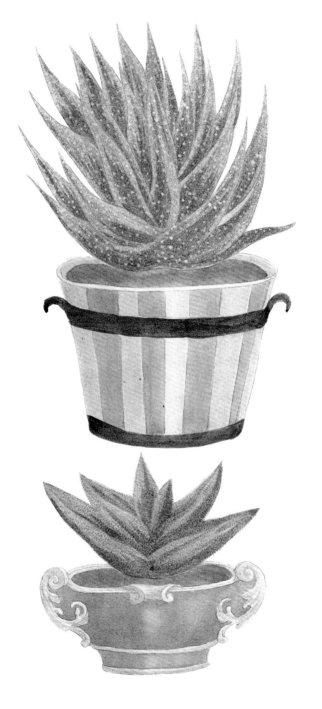

N. 55

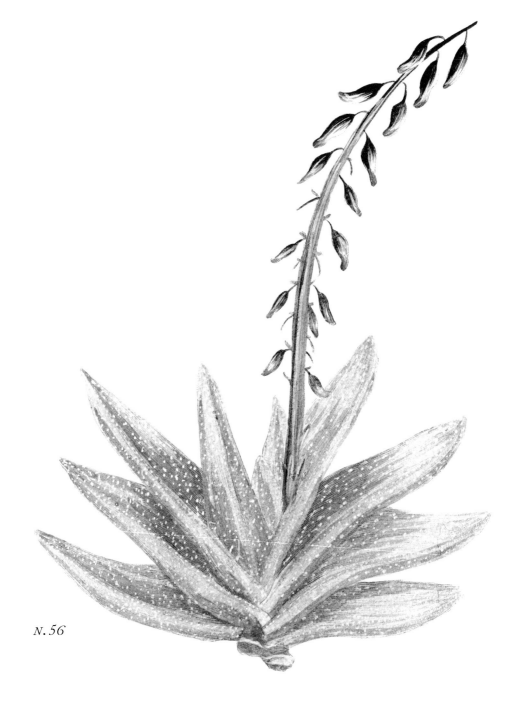

N.56

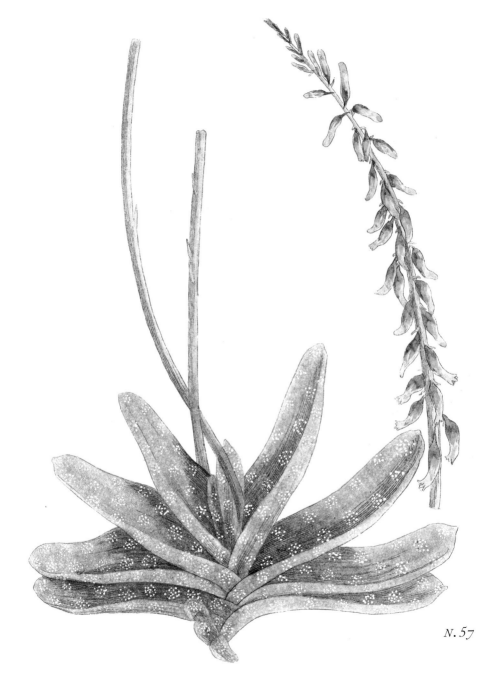

N. 57

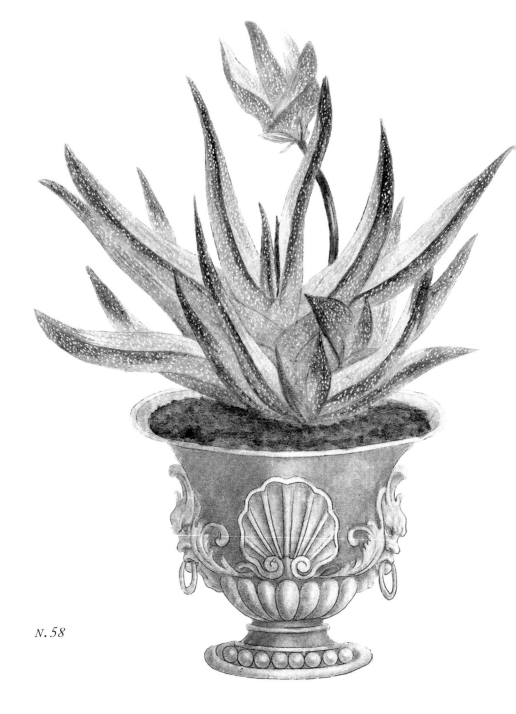

N. 58

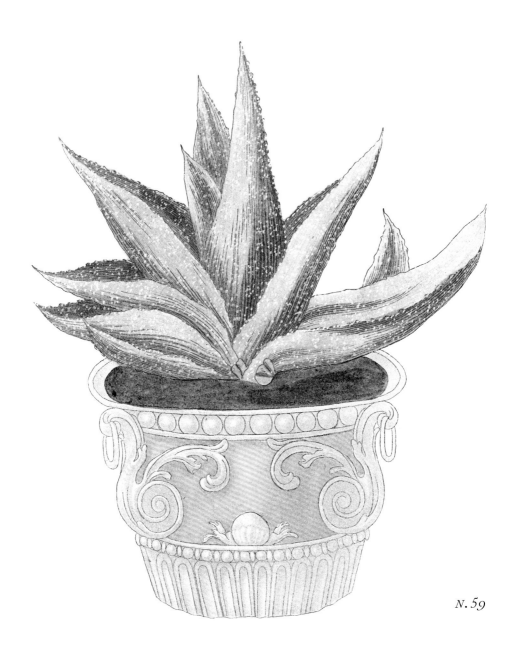

N. 59

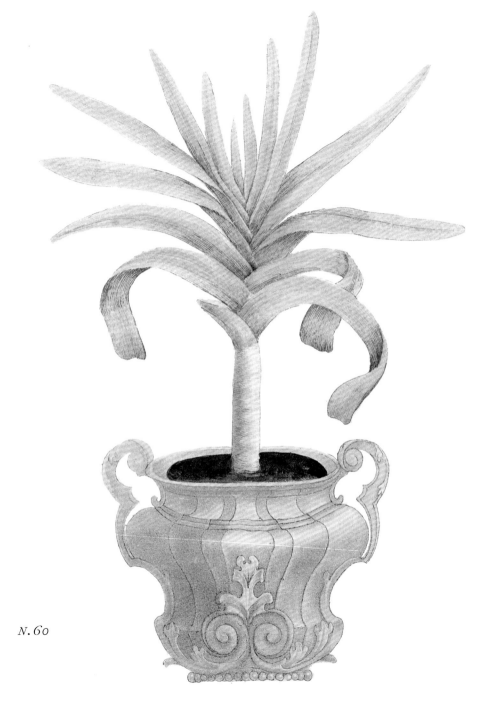

N.60

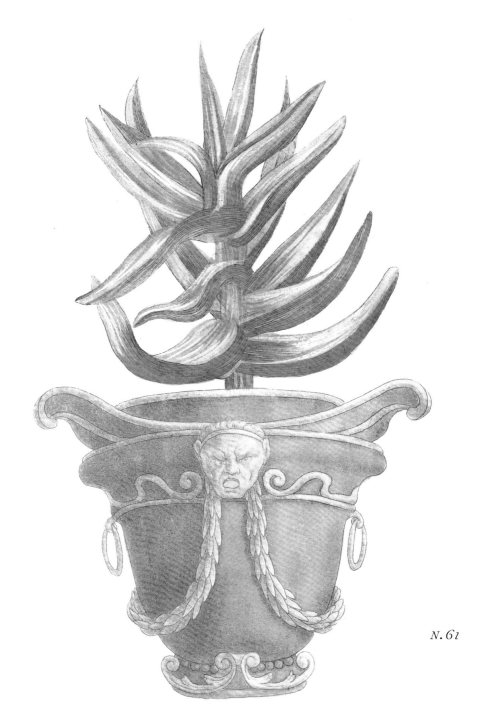

N. 61

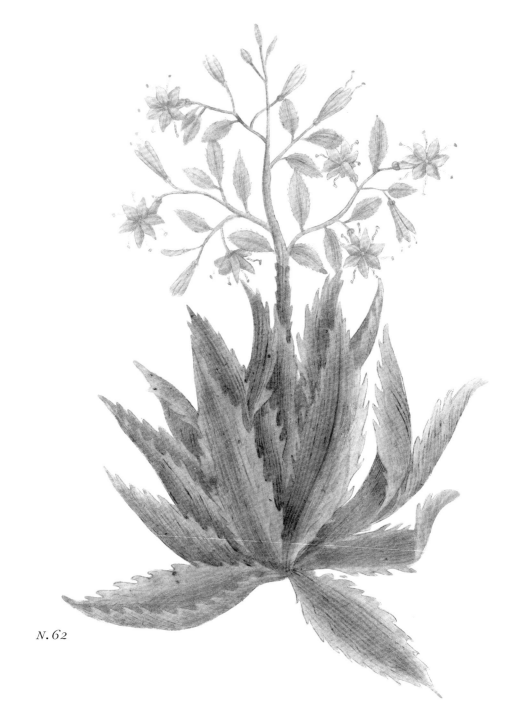

N. 62

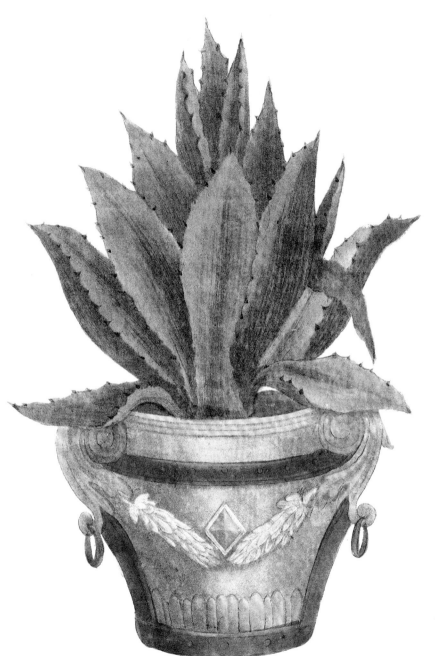

N. 63

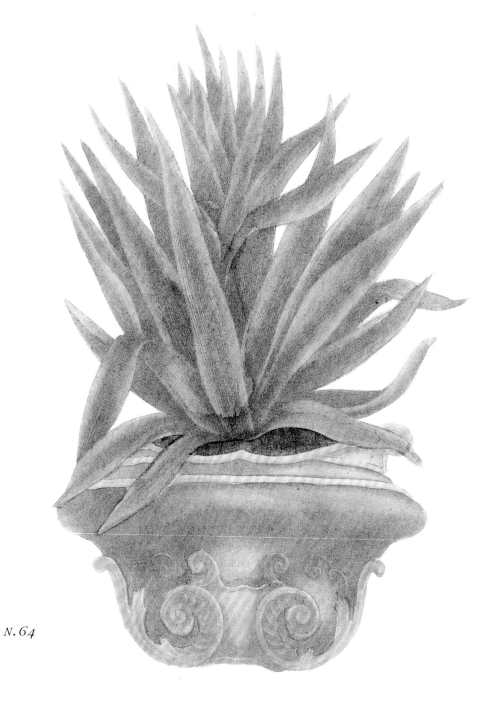

N. 64

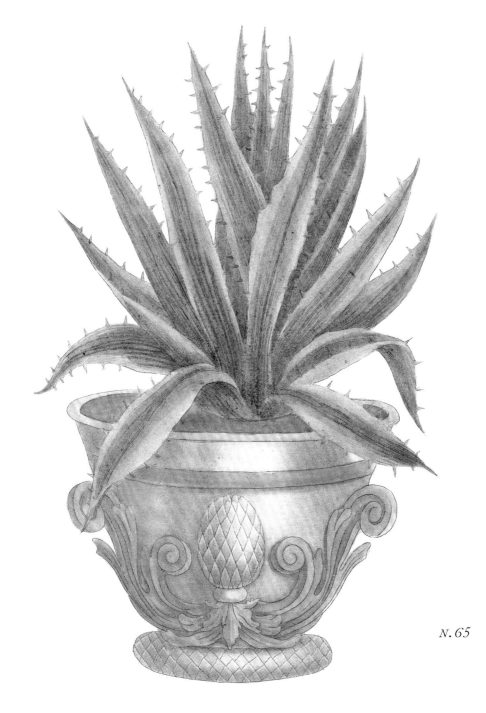

N. 65

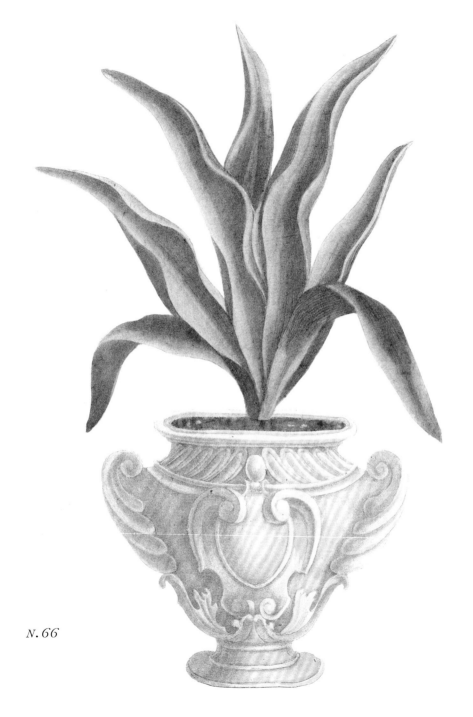

N. 66

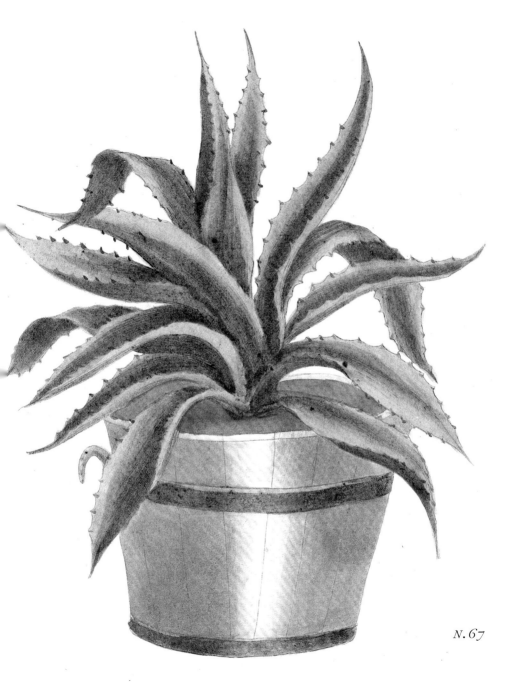

N. 67

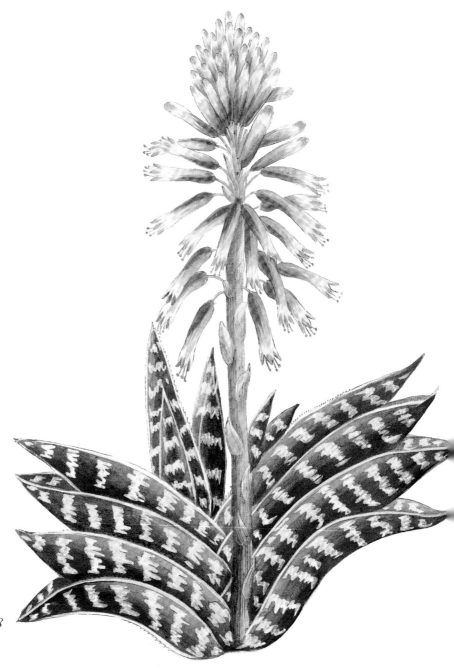

N. 68

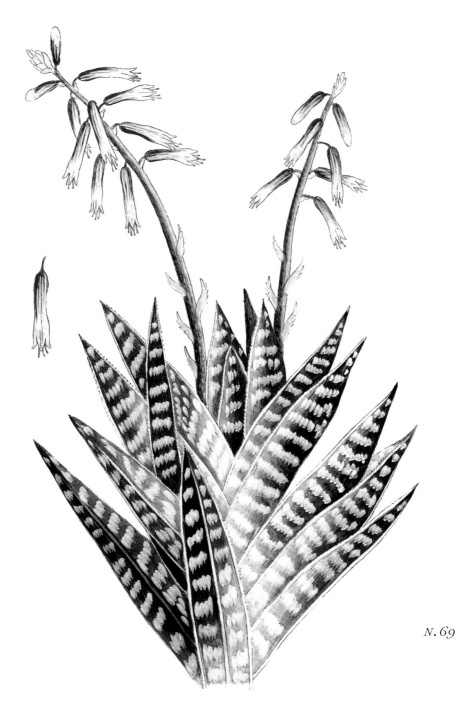

N. 69

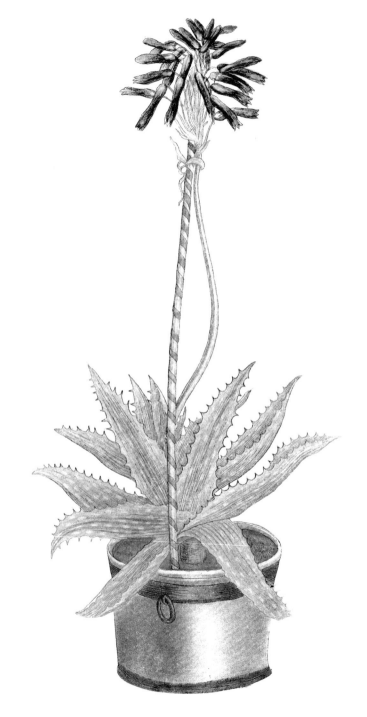

N. 70

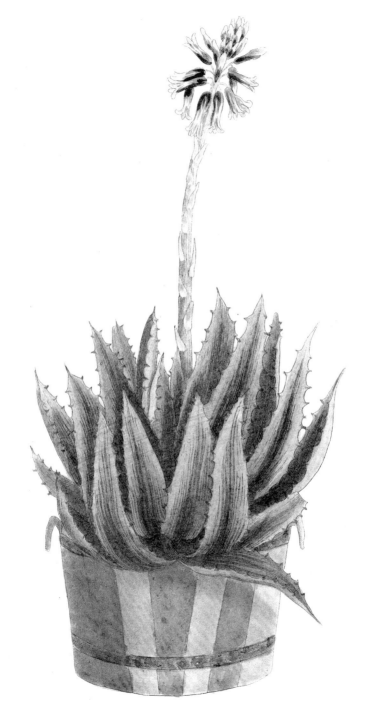

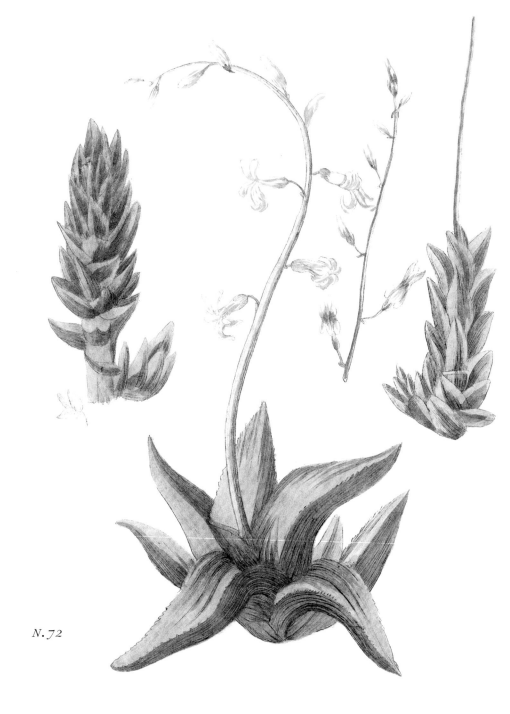

N. 72

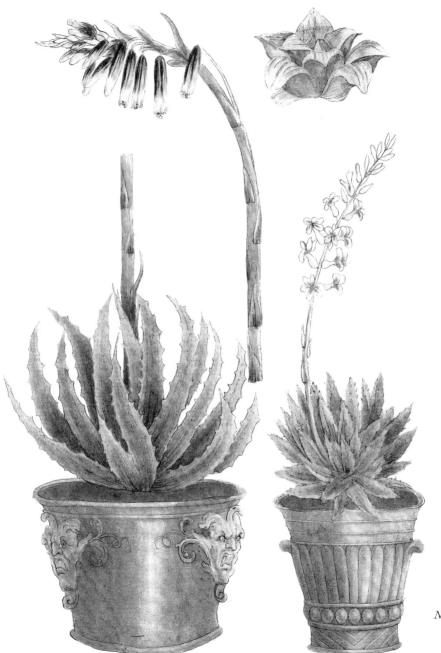

N. 73

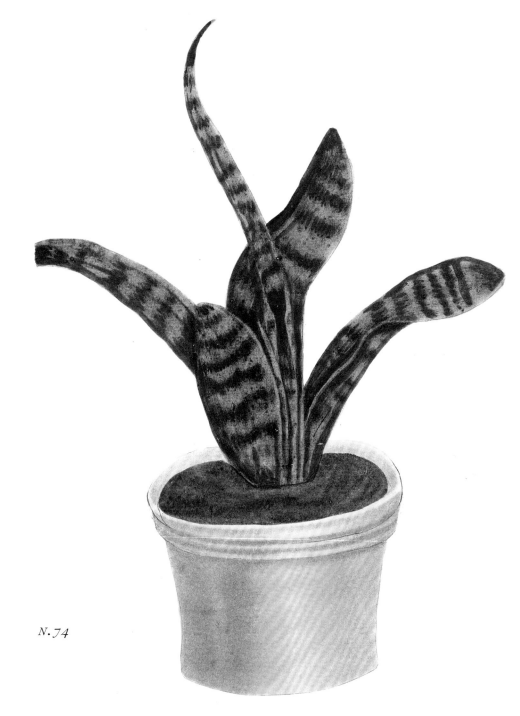

N. 74

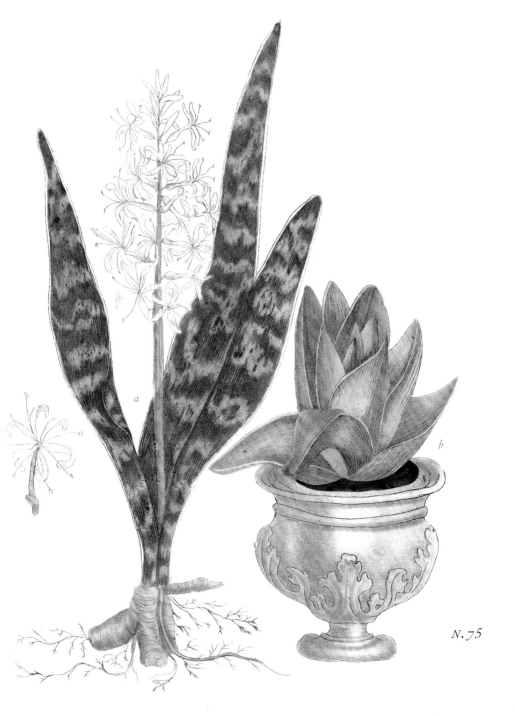

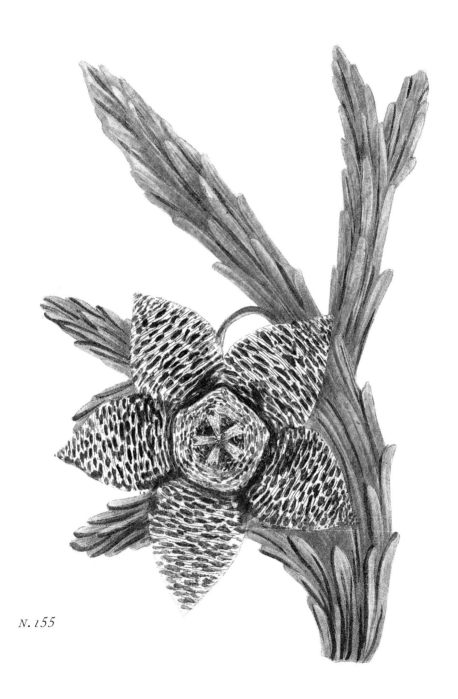

N. 155

N. 156

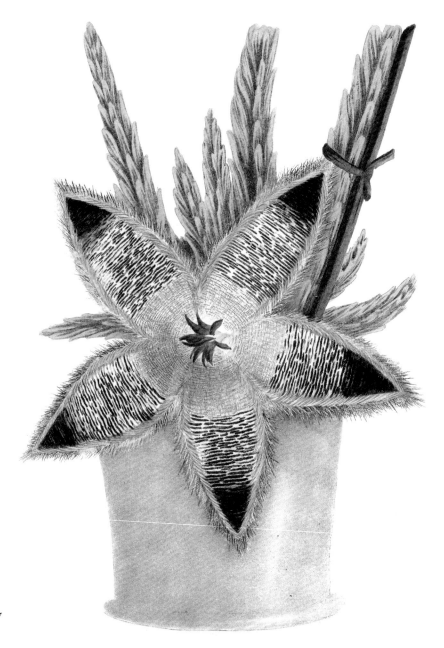

N. 157

N. 276

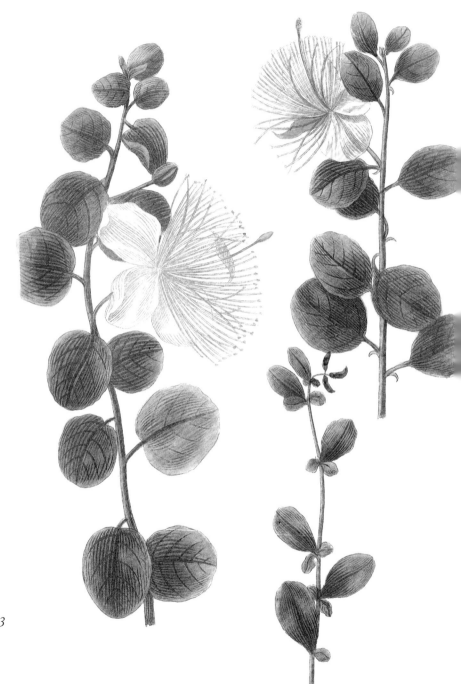

N.303

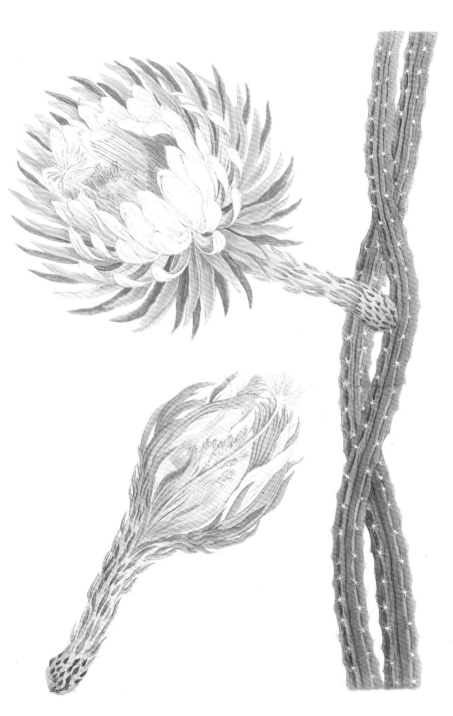

N.354

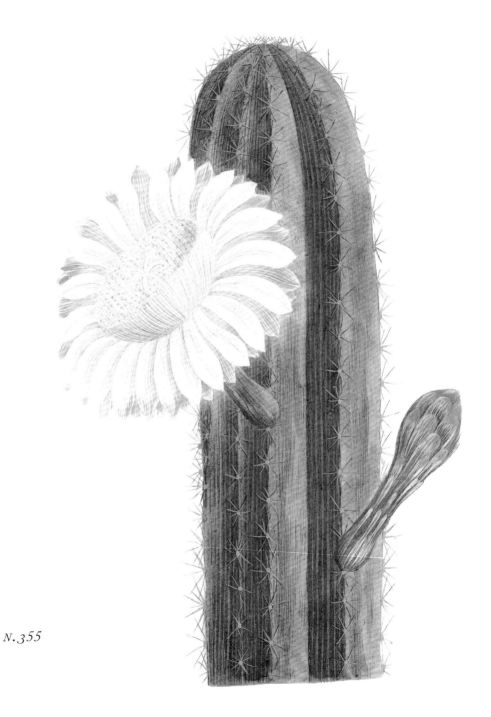

N. 355

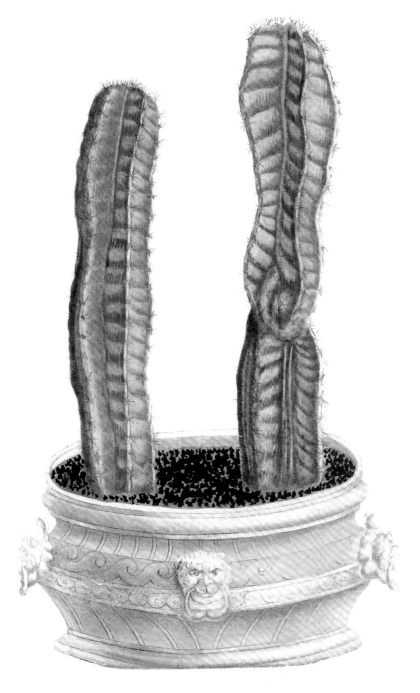

N.356

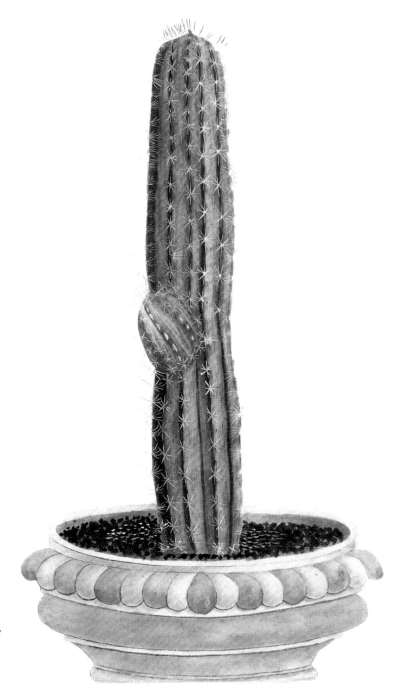

N.357

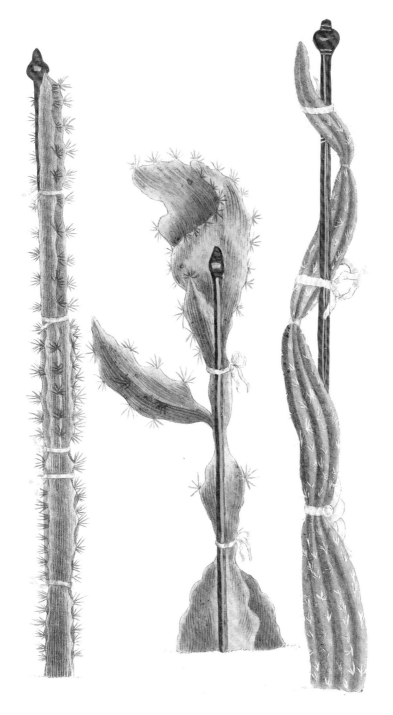

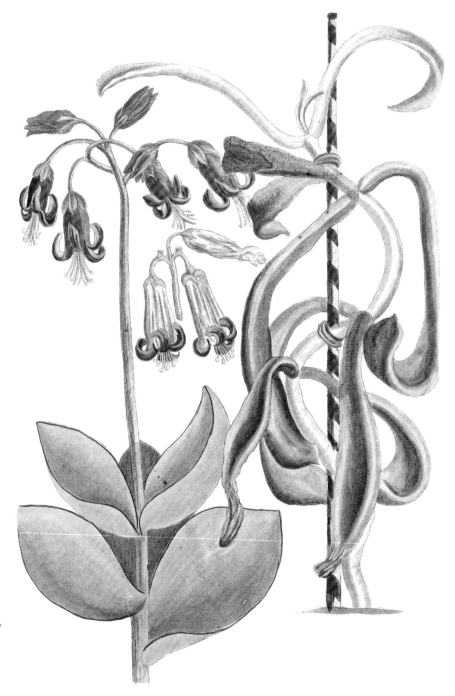

N. 433

N. 434

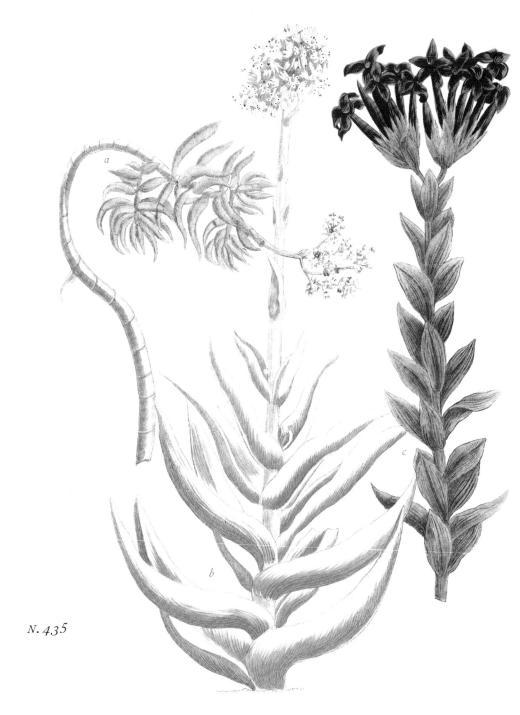

N. 435

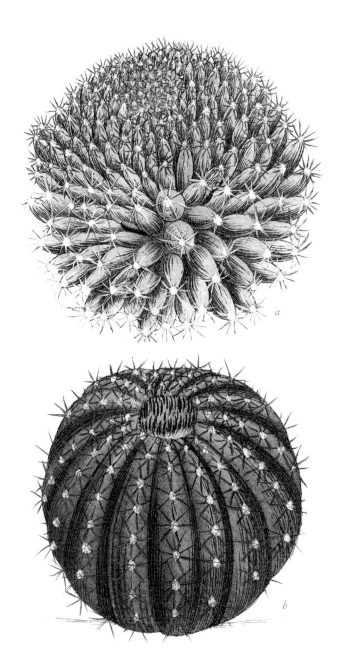

a

b

N. 474

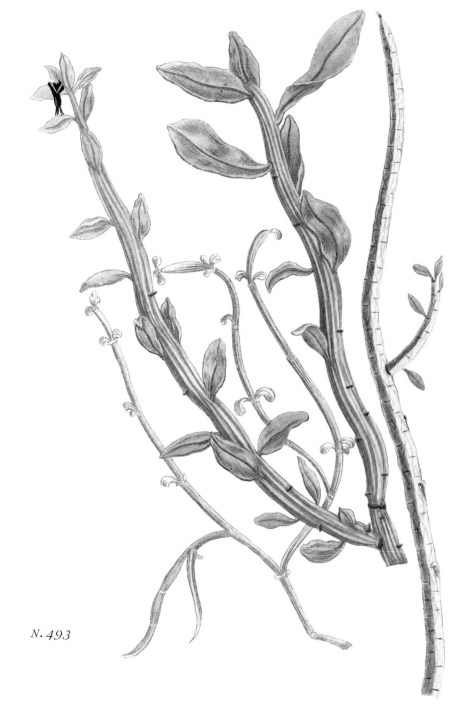

N. 493

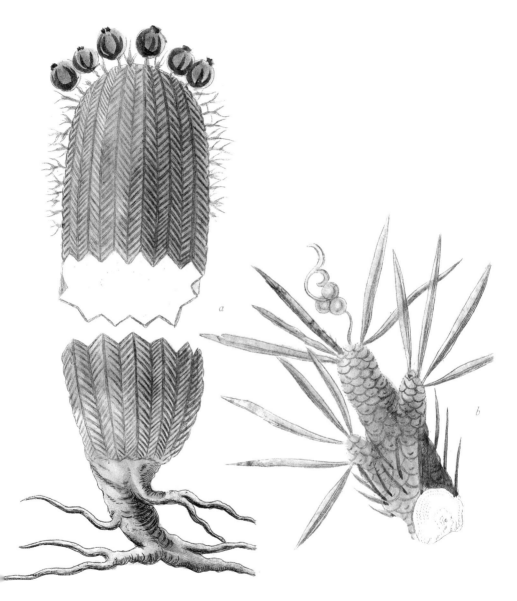

a

b

N. 494

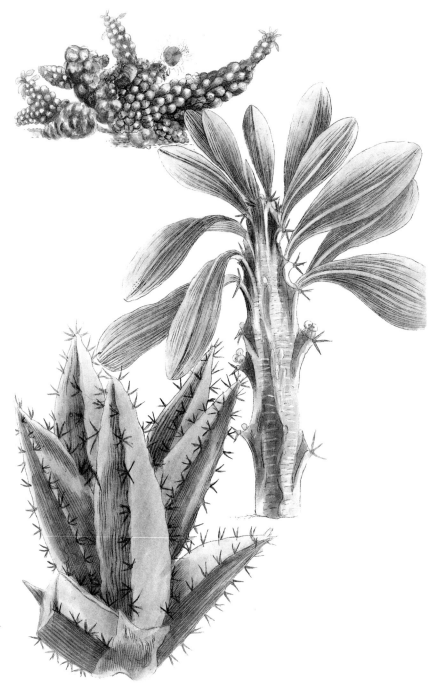

N. 497

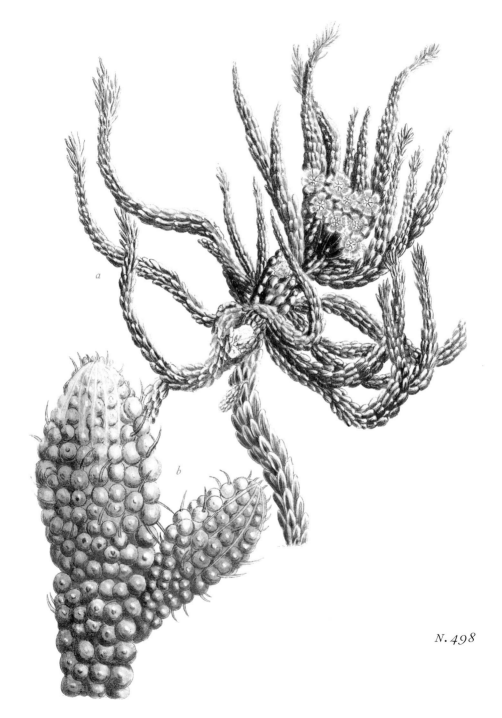

N. 498

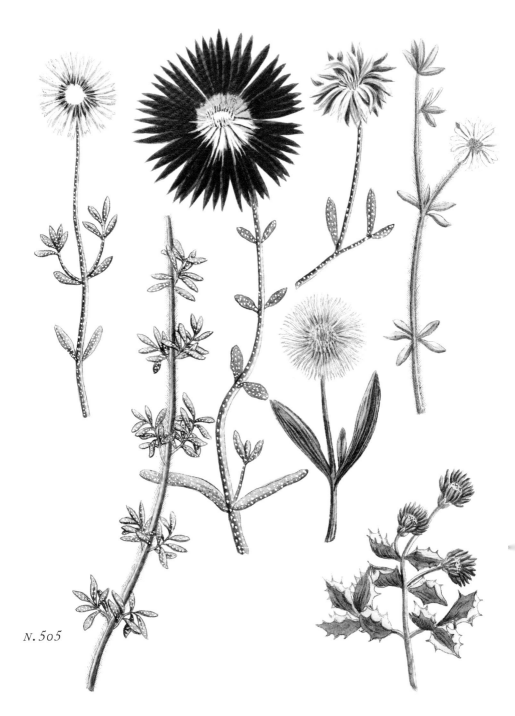

N. 5o5

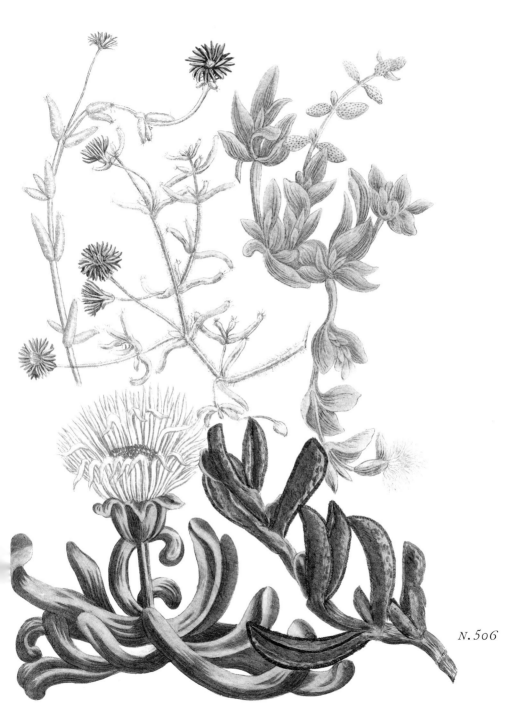

N. 5o6

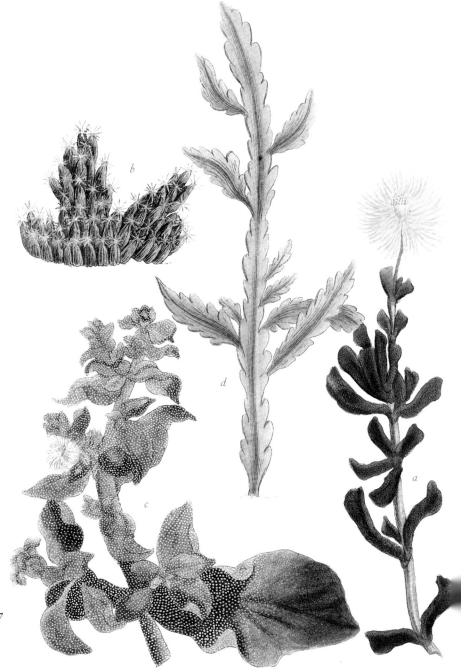

N.507

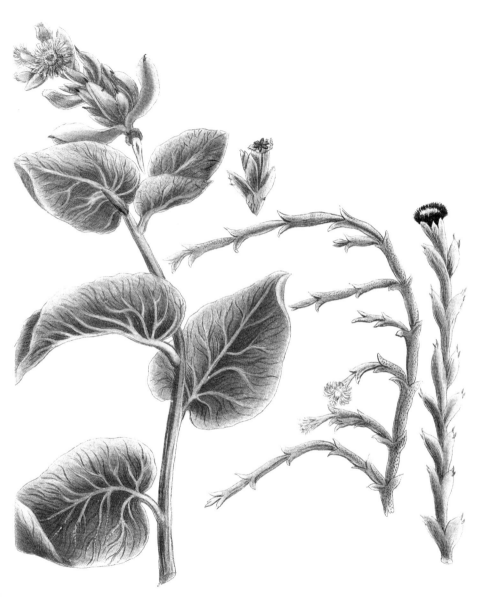

N.508

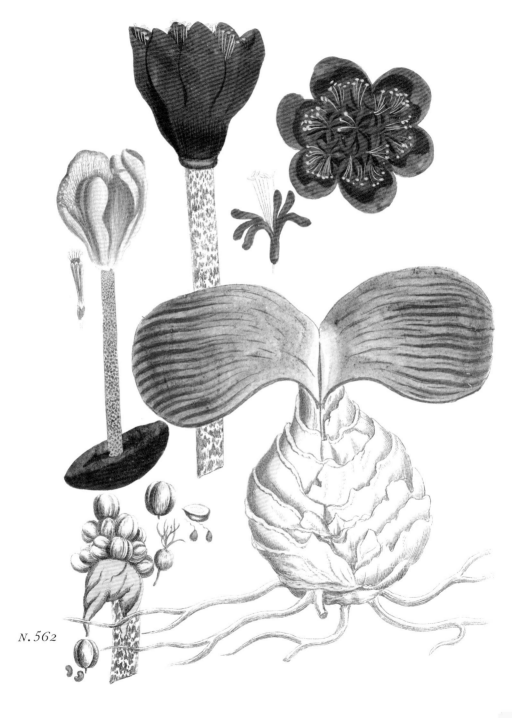

N.562

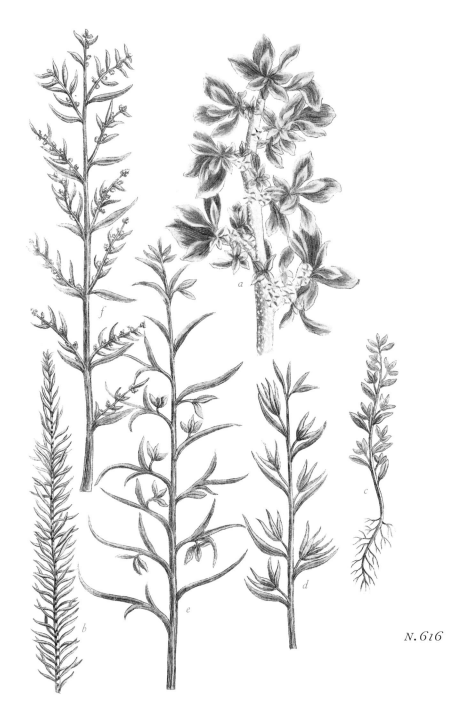

N. 616

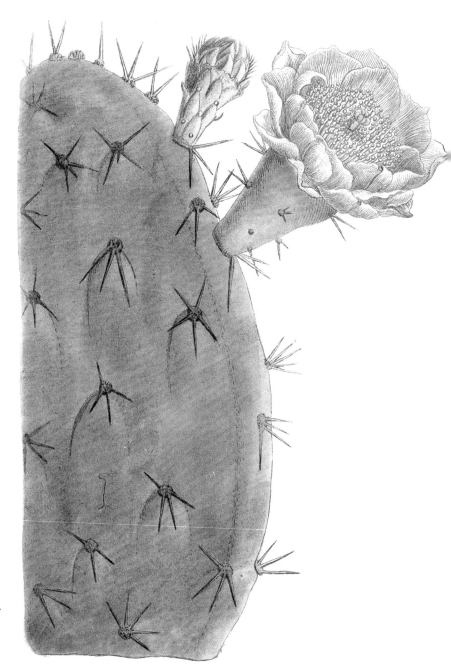

N. 765

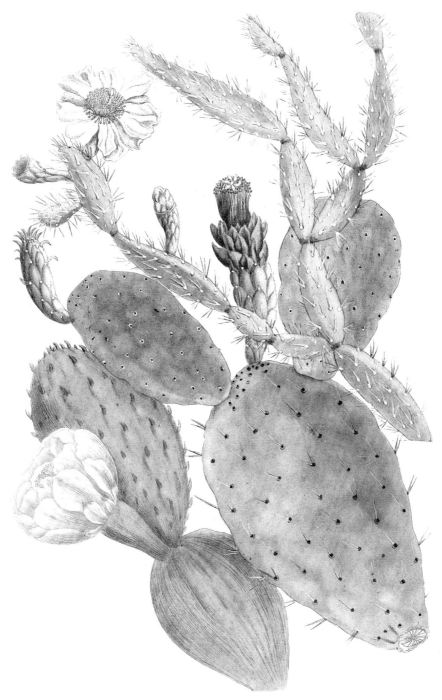

N. 766

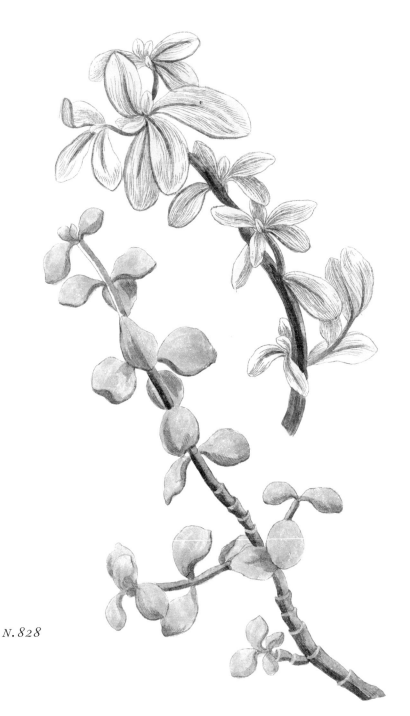

N. 828

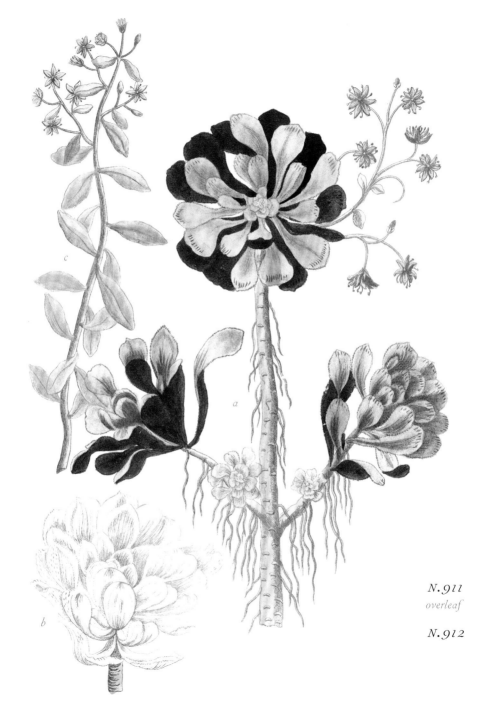

N.911
overleaf

N.912

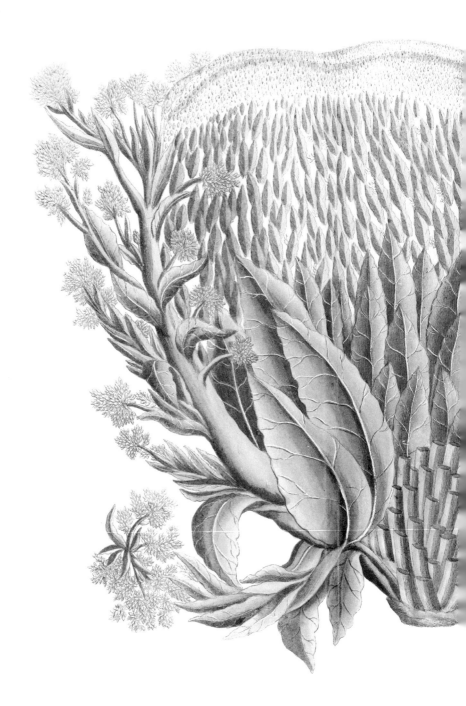

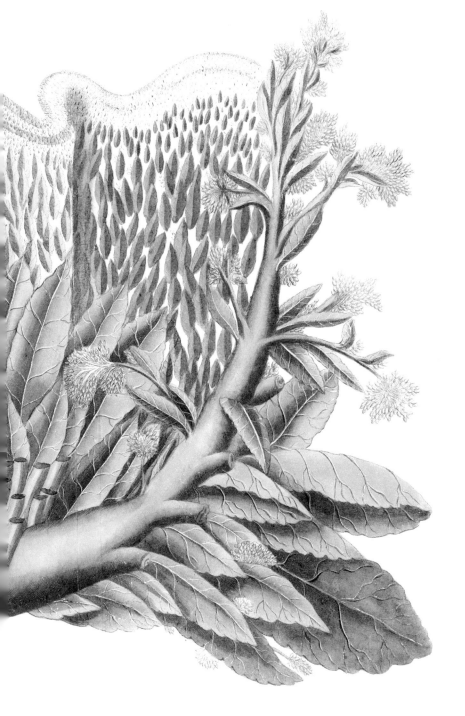

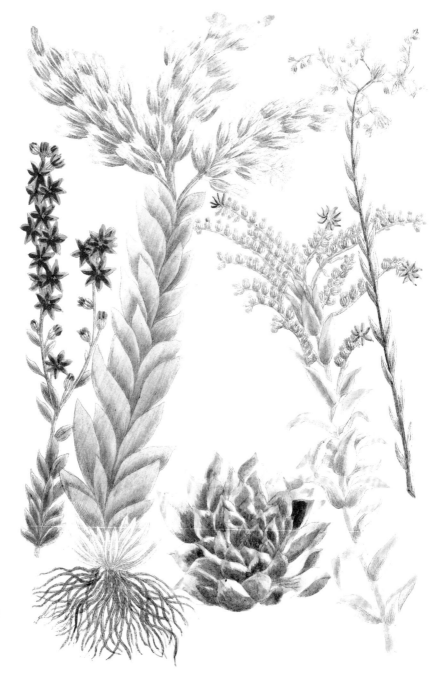

N.913

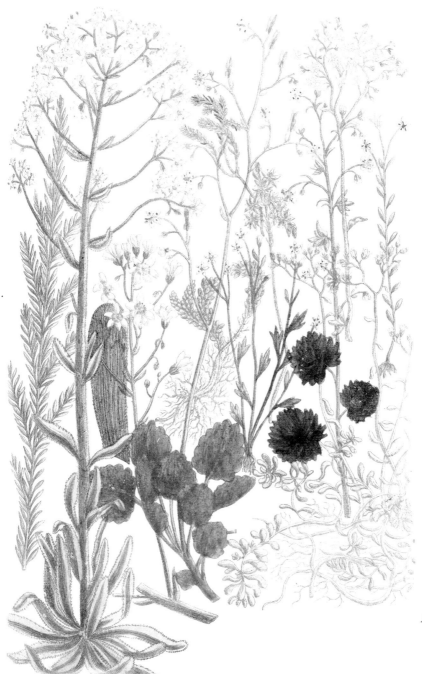

N. 914

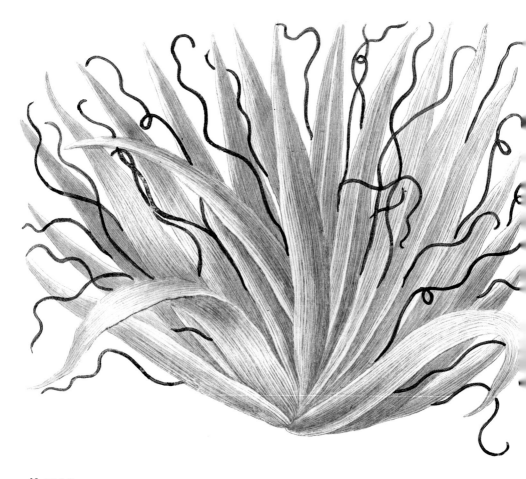

N. 1022

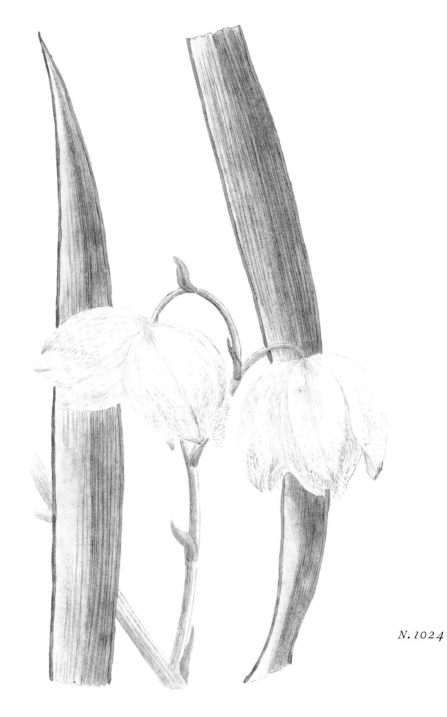

N. 1024

About the illustrations

Except where indicated, the headings refer to the original names given in the *Iconographia*.

One of the highlights of the *Iconographia* is the large section on aloes, perhaps reflecting Weinmann's personal interest – details of the majestic *Aloe Americana* he grew are on page 31. Many of the specimens are shown complete with their highly ornate pots, which is how they would have been displayed in the glasshouses or 'exotic gardens' of collectors.

Historically, bitter aloes was commonly used as a purgative and bowel regulator (described by Dr William Lewis in his *Materia Medica*, 1784, as 'particularly adapted to persons of a phlegmatic temperament and sedentary life'). Its source was the sap of several aloes, usually dried to powder or a rubbery cake. Since aloes were so much in demand for their therapeutic properties, they were one of the plants Columbus was charged with finding in the New World. Sure enough he came back with a number of species of what for more than 200 years were called 'American aloes', until Linnaeus renamed them agaves.

Not all the aloes Weinmann described are classified as such today – they have been marched off to other homes such as *Gasteria*, *Haworthia*, *Sansevieria* and even, in the case of N45a, *Kniphofia* (red-hot poker), as well as *Agave*. However, it seemed more pleasing to keep them all together here, as they were originally presented in the *Iconographia*.

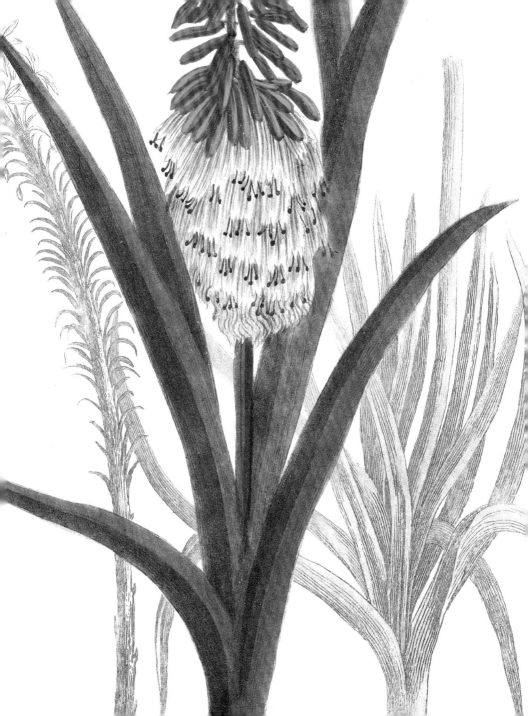

In modern taxonomy, flowers are a key classifier, and so N56 and N57 can be identified as gasterias by their distinctive stomach-shaped flowers (hence the name), and the very different flower stems of N73 help to show why the plant on the right is now considered a haworthia rather than an aloe. The species on N44 is the aloe probably best known today: *Aloe vera* (aka *A. barbadensis*), still valued for soothing burnt or broken skin. The banded leaves on N74 and N75a are easily recognizable as that once indispensable windowsill plant mother-in-law's tongue (*Sansevieria* or *Dracaena* spp.).

Apocynum see *Stapelia* N155–7

Cacaliastrum N276

This fleshy-stemmed succulent is a native of the Canary Islands. When it loses its leaves in summer – another water-saving ploy – the naked branched stems look rather like a mass of deer antlers. The plant grows into a fair-sized shrub, about the height of a man or taller, and when the flowers we see here develop their fluffy seed heads they present an arresting sight. The *Iconographia* labelled it *Cacaliastrum* or *Senecio arborescens nerii foliis* ('with oleander-like leaves'), but over the years it accumulated many different names. It is now officially *Kleinia neriifolia* although still often called *Senecio kleinia*.

Capparis N303

The capers that we know as little round green buds, typically preserved in brine, come from this plant, *Capparis spinosa*. The same bush is also the source of the larger caperberries, which are, as the name implies, the fruits that form after the pretty feathery flowers are allowed to develop. These fragrant bushes grow wild all around the Mediterranean, and their semi-succulent leaves allow them to thrive in rocky crevices.

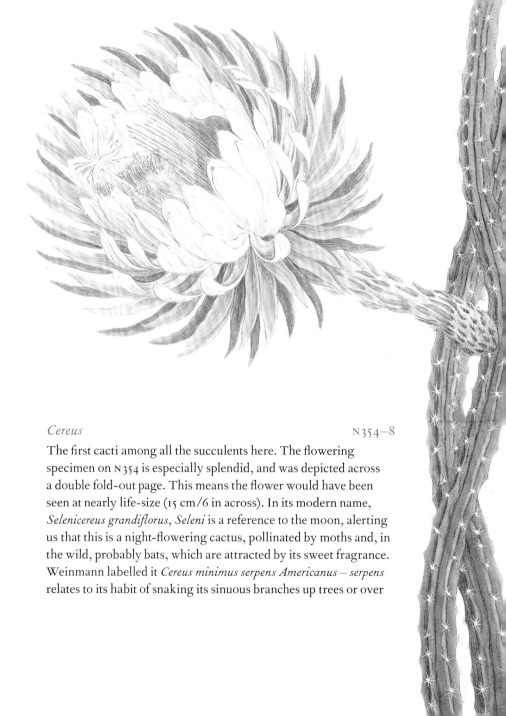

Cereus

The first cacti among all the succulents here. The flowering specimen on N354 is especially splendid, and was depicted across a double fold-out page. This means the flower would have been seen at nearly life-size (15 cm/6 in across). In its modern name, *Selenicereus grandiflorus*, *Seleni* is a reference to the moon, alerting us that this is a night-flowering cactus, pollinated by moths and, in the wild, probably bats, which are attracted by its sweet fragrance. Weinmann labelled it *Cereus minimus serpens Americanus* — *serpens* relates to its habit of snaking its sinuous branches up trees or over

rocks. The cacti on N358 are shown strapped to stakes for display purposes, but in nature would similarly have sprawled, though their spindliness may have been exacerbated by lack of light in cultivation.

The species on N355, with its showy flower, is labelled as originating from Surinam. The two very similar specimens sharing a pot on N356 are differentiated by their number of vertical ribs: *C. quadrangularis* on the left has four, while *C. quinqueangularis* on the right has five.

Cotyledon N433–5

These generally small succulents, most of which originate from South Africa, are popular as houseplants in cooler climes. Weinmann quoted the Greek physicians Dioscorides and Galen as recommending the mildly astringent sap and leaves of cotyledon for 'cooling hot stomachs' and dispersing kidney stones, but they are now mostly seen as purely ornamental, although the sap of some is traditionally used to cure warts and verrucas.

Like many succulents, cotyledons have evolved multiple ways to reduce water loss. Their fleshy stems and leaves are typically slightly waxy, and some have the protection of a farinaceous (floury) or fine-haired covering, giving them a silvery or velvety appearance. The few common names attached to cotyledons often pick up on this. *Cotyledon tomentosa* is called bear's paw, because its extra-thick leaves are distinctly furry and edged with tiny 'claws', and the almost white example on N434a is probably *Cotyledon orbiculata*, known as pig's ear. As is common with cotyledons, the red margin to the leaves becomes more pronounced in strong sunlight.

Botanists have now reclassified many into other genera, including *Tylecodon* (devised as an anagram of *Cotyledon*) and *Crassula*. The

silvery plant on N435b that Weinmann labelled *Cotyledon Aloes facie perfoliatum* is probably now identified as *Crassula perfoliata*. It can grow to about 1.2 m (4 ft).

Echinomelocactus N474

Echinomelocactus – 'spiny apple-shaped cactus' – is an appropriate name but quite a mouthful. Nowadays they come under several genera, but are collectively referred to as barrel or globular cacti. The name 'cactus' comes from the Greek *kaktos* and was originally used for thistly globes such as cardoons and artichokes. In the sixteenth century the plantsman Matthias de L'Obel (the lobelia was named after him) grouped them with artichokes in his seminal botanical works, while Weinmann recorded the English name as 'Hedge Hogge Thistle'.

Although the two specimens shown on N474 both originated in the Caribbean and appear much the same size, they are actually quite different. The one on the top, labelled *minor*, is likely to be a *Mammillaria mammillaris*. It was one of the first to be discovered by Europeans. It seldom exceeds 20 cm (8 in) in diameter. In contrast, the one on the bottom, labelled *major*, is a *Melocactus*, a form of barrel cactus, which

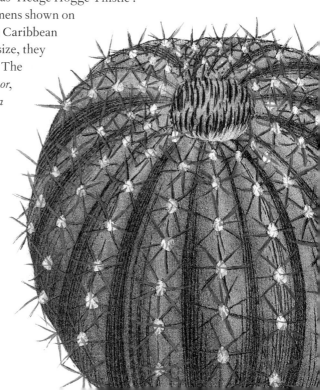

slowly grows to large proportions – about the size of a barrel, in fact. The tufty pink crown is a distinctive feature of some cacti species, called a cephalium. It develops only once the plant has reached maturity and moved on to its flowering and fruiting stage, and it is from the cephalium that the cactus's often showy flowers will emerge.

Euphorbium and Esula N 493–4, 497–8

The euphorbia family is enormous – around 2,000 species – and immensely varied. Perennial or shrubby euphorbias are familiar garden plants (and weeds) in temperate zones, while in hotter climates through South East Asia, Africa and the Americas the family ties together species as dissimilar as the snaky Medusa's heads (see N 498a) and poinsettia (*E. pulcherrima*), whose flamboyant scarlet bracts have made it so popular as a Christmas pot plant.

Nearly half the species in the family are succulent to some degree, and some can easily be mistaken for cacti. While they are botanically quite unrelated, it is not really surprising that plants that have had to adapt to, for example, the arid expanses of Africa should have developed along the same lines as those that evolved in the New World's deserts. The specimens on N 497 are good examples of these African 'cacti', but the sturdy plant at the bottom of the page is a real curiosity. Although Weinmann identified it as *Euphorbium supinum squamosum* (roughly: laid-back and scaly), it was singled out by the late, great Gordon Rowley as an imposter!*

Esula is now a subgenus of *Euphorbia*, and although in the *Iconographia* it is a stand-alone group of leafy spurges, a couple of

* Gordon Rowley (1921–2019), world-renowned succulent expert and prolific author, drew attention to this oddity in his *A History of Succulent Plants*, in which he captioned this image from the *Iconographia*: 'Two genuine euphorbias and a mythical one'.

distinctly succulent
varieties feature; N494a is
identified as 'spiny candle-
shaped African Esula or
Tithymalus'.

When cut, euphorbias
ooze a caustic latex-like
sap that (as gardeners will
know) can burn and blister.
But, like so many medicinal
plants, this potential
danger was harnessed for
its healing properties. The plant's common name of spurge indicates
its former use as a purgative, and it was also used to reduce fever and
inflammation, as well as being, according to Weinmann, 'in daily use
by surgeons in treating gangrene'.

Ficoides N505–8

Many of the millions of flowers that contribute to the wondrous
blooming of the southern African veldt are the small, brilliant daisy-
like flowers that are grouped together in the *Iconographia* as *Ficoides*.
(The name, meaning 'fig like', was attached to them because the seed
capsules were perceived to resemble figs, to which they are not related.)

Today they have been saddled with a slew of names – *Drosanthemum*,
Lampranthus, *Trichodiadema* and the like – that seem too weighty for
these bright, delicate plants. The best known to temperate gardens are
probably the mesembryanthemums.

Several are commonly called ice plants, and specimen c on N507
(*Mesembryanthemum cristallinum*) shows most clearly why. Translucent

little sacs covering the surface of its leaves and stems hold water, giving the whole plant a glittering appearance. Weinmann described it as 'sprinkled all over with crystals'.

Haemanthus

The blood lily or paintbrush lily might be described as a semi-succulent, and part-time at that. It has several characteristics that enable it to survive in its arid homelands in South Africa and Namibia: fleshy leaves that earn it a place here, but also a large bulb to store food and water, and the habit of going dormant in the summer.

Unlike most of the images in the *Iconographia*, this attempts to record all the elements of the plant in a way that was to become standard practice in botanical art. So we are shown not only the bulb sprouting its pair of thick leaves, but different views of the flower (which is technically a head of multiple flowers surrounded by a cup of scarlet bracts), as well as the seed pods and the seeds they contain.

Kali

The glassworts are succulents with a difference, and definitely fall into the 'botanical succulent' rather than 'horticultural succulent' camp. They have developed fleshy leaves and stems, not because of lack of access to water – they grow in salt marshes and beside the sea – but to enable them to survive their salt-laden environment.

The *Iconographia* describes the process of burning kali plants to extract sal alkali or soda ash (the name 'kali' comes from the same Arabic source as 'alkali'). It had long ago been discovered that the ashes of these plants were extremely high in sodium carbonate, which for centuries was used in the manufacture of glass, hence their common name, and in soap-making.

Several forms of these plants are edible – samphire is a relation – and there is currently renewed interest in all plants, kali included, that can tolerate a saline soil, both for food and for biofuels.

Although the two stems in the middle of N616 (d&e) look soft and feathery, they are forms of prickly saltwort (*Kali/Salsola turgidum*); each fleshy leaf ends in a minute but very sharp spike.

Opuntia

N765–6

Opuntias originated in the Americas and the Caribbean but adapted enthusiastically to life in locations as far afield as Spain and Australia, and in places have become a menace (see page 11). They are one of the largest groups in the cactus family, with a range that stretches from the Canadian Rockies to the southern Andes.

Opuntias are commonly called prickly pears, but have a variety of local names, including nopal, cholla and bunnies' ears. The juicy pads are good to eat and will frequently feature on menus, especially in Mexico, as *nopales*. The fruit, too (confusingly called *tuna* in Spanish), is delicious, but both pads and fruit must be very carefully peeled first because of a distinctive feature that is good protection for the plant but unwelcoming to animals and humans. As well as regular spines, opuntias have tiny hair-like spines called glochids. These are barbed like a fish hook and detach from the plant at the slightest touch – even wind can blow them off. Once embedded in your skin they are very difficult to remove and a major irritant.

Prickly pears are often recommended for their health benefits, and research continues into their possibilities, especially in regulating cholesterol and diabetes. John Gerard wrote about four cacti in his celebrated *Herball* (1597), including an opuntia or 'prickly Indian Fig

tree' – his main health note was that people found that eating the fruit 'changed their urine to the colour of blood'.

Portulaca

N828

The Portulacaceae family as a whole is much fragmented, but the type that Johannes Weinmann knew and employed was the small creeping herb called purslane (*Portulaca oleracea*). It has long been used as a culinary herb throughout the Mediterranean, but he also valued it, as had the Ancient Greek physicians before him, for a wide range of medicinal uses. It would be recommended in applications as varied as warding off scurvy (it does have good levels of vitamin C), rebalancing the four humours that were believed to govern a person's health, and relieving toothache. Today its soft crunchiness and tangy leaves are best appreciated as additions to salads and stir-fries.

Sedum

N911–14

Although we most readily associate succulents with hot, dry regions, sedums are familiar plants in cooler temperate areas, even cold mountainsides. Many of them have evolved to cope not with burning sun or lack of rainfall, but with rocky terrain that doesn't retain moisture. One of their common names is stonecrop.

The related houseleeks (*Sempervivum* spp.) are grouped together with sedums in the *Iconographia*. Sempervivums typically form distinct rosettes that after several years throw up a rather phallic flower stem and then die, leaving behind many smaller rosettes. Sedums, on the other hand, generally form spreading mats of small leaves and flower every year. Both are popular choices for green roofs.

Among the dozen or so varieties that the *Iconographia* depicts, two particularly stand out. *Sedum Africanum monstrosum* on N911 certainly

is a monster. It is not a separate species, but a mutation has caused it to develop multiple growth points, resulting in overcrowded, curling formations. It has become quite popular to graft one of these mutations onto a 'normal' succulent to produce so-called Frankenplants.

The large rosettes on N912 are now called *Aeonium arboreum*. They are native to the Canaries but have naturalized in suitable habitats around the world and can grow to 2 m (6 ft or more). The pale, pink-rimmed variant described as *foliis pictis* (with painted leaves) is a variegated version, of which many have since been bred.

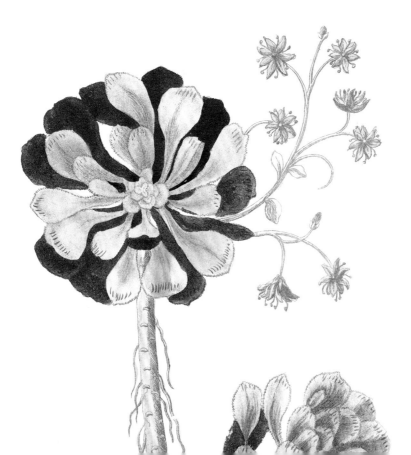

A number of plants – lambs' ears (*Stachys byzantina*), for example – have developed furry leaves as a defence against hot sun. Many stapeliads (stapelias and their relations) have gone one stage further, and have furry *petals*. Combined with the liverish stripes and spots of many varieties they can have a slightly menacing, almost carnivorous look. This is underscored by the distinctive smell, definitely not fragrant, they emit to attract flies for pollination – one of their common names is 'carrion flower'.

The hairy-flowered *Stapelia hirsuta* (N157) is typical, with flowers around 15 cm (6 in) across. Though impressive, they are outclassed by the blooms of *S. grandiflora* and *S. gigantea*, which can be twice or even three times as wide.

The first stapelia to arrive in Europe from its home in South Africa was *S. variegata*, in 1639 (N155). In the *Iconographia* it is labelled variously *Apocynum*, *Fritillaria crassa* and *Stapelia* but is currently *Orbea variegata*. Stapelias are particularly prone to the mutation described on the previous page, and the image on N156, captioned *monstrosa*, is almost certainly one of these, referred to as crested or *cristata* forms.

Yucca N1022, 1024

Yuccas are another 'borderline succulent'. They have adapted to desert habitats in a number of different ways, and for some this includes storing water in their thickened leaves or, in the case of *Y. elephantipes*, in a swollen trunk (see page 2).

Yuccas are in the same subfamily as agaves. Their juicy sap was traditionally used in some of the same ways as aloes, such as to soothe the skin. Indeed, some of Weinmann's aloes have since been reclassified as yuccas, including those on N52, N53 and N75b.

Weinmann devotes almost twelve columns to descriptions of yuccas and their uses, but most of it relates to a completely different plant: the Yuca (below). Yuca was the name by which cassava or manioc (*Manihot esculenta*) was known throughout Central America and the Caribbean, but the two plants got accidentally confused, even though the only link is similarity of habitat. This misunderstanding was perpetuated by Linnaeus in his naming of Yucca.

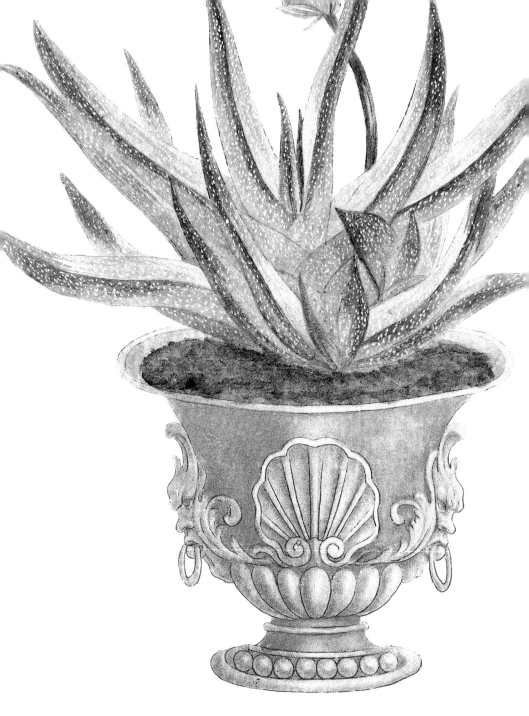

Where to see succulents & cacti

Encounters with succulents will depend on where in the world you are – what are carefully tended exotics in cooler climates can be everyday sights and even unwelcome weeds in a succulent's natural habitat.

To appreciate the scale and variety of the great cacti, there is nothing quite like visiting them on their home territory. The Saguaro National Park and the Sonora Desert Museum in Arizona, and California's Huntington Desert Garden, are just three examples in western North America that offer breathtaking sights, though collections are to be found in almost every state of the USA. These can be found even in unexpectedly urban locations, including Garfield Park Conservatory in the middle of Chicago, the Getty Center's rooftop cactus garden overlooking the sprawl of Los Angeles and the architecturally striking Desert Dome in Milwaukee's Mitchell Park.

There are succulent gardens and collections to be visited the length of the Americas, from Toronto's Allan Gardens, which features some unusual specimens such as African euphorbias, to Chirau Mita in Argentina, believed to be the oldest garden dedicated to cacti in Latin America. Here some twelve hundred species grow on terraces within sight of snow-capped mountains. An especially rewarding 'hunting ground', though, is Mexico.

Mexico is the native home of an estimated 60 per cent of cactus species. Just a few of the many fascinating sites to explore include the beautifully designed Jardín Botánico de Cadereyta and La Quinta Schmoll, home to some ancient giant cacti, both in central Mexico. A couple of hours' drive west is Charco del Ingenio, a long-abandoned canyon that has been largely left to regenerate and is now a treasured nature reserve of endemic flora, with more than eighty species of opuntia and many other cacti. The Jardín Etnobotánico in the southern province of Oaxaca (the region from which the adventurer de Menonville tried to smuggle out cochineal insects, see page 11), is created around a former monastery. UNAM, in Mexico City, has the second oldest botanical garden in the country and, like university gardens the world over, it focuses on research and education as well as allowing the public to enjoy its collection of more than fifteen hundred indigenous species.

Research was often the spur for collections. In Britain, a number of university botanical gardens have succulent collections that anyone can visit, including those of Durham and Cambridge and, in Scotland, Edinburgh and Duthie Park in Aberdeen. The Arid House in Oxford University's 400-year-old Botanic Garden houses giant euphorbias over a century old. Presentation of these plants so far from their native lands varies hugely. Gardens of world renown such as Kew and the Royal Horticultural Society Gardens at Wisley have majestic glasshouses dedicated to their arid collections, while the World Garden in Kent is in the grounds of historic Lullingstone Castle, and Winterbourne, an outpost of Birmingham University's botanic gardens, is set in the domestic charm of an Edwardian house. At Ventnor Botanic Gardens, on the Isle of Wight, the climate is balmy enough to eschew cover

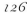

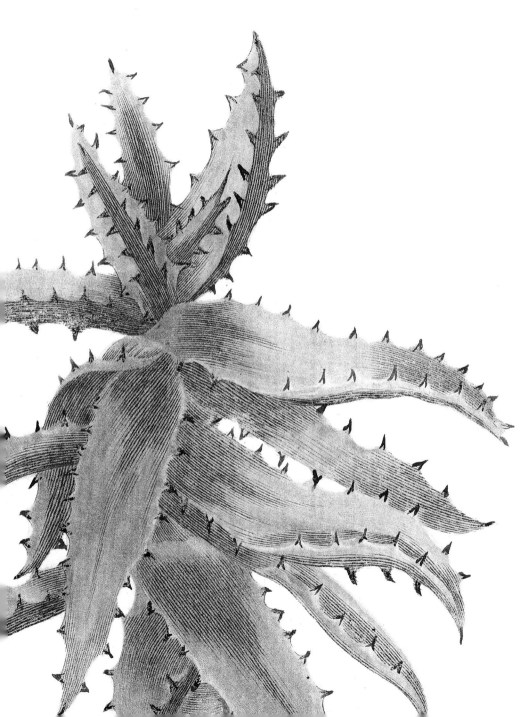

altogether. The British Cactus and Succulent Society produces a useful guide to succulent collections around Britain that are open to the public.

Grand succulent houses can be found in botanical gardens all over northern Europe – in Prague, Munich (in Johann Wilhelm Weinmann's adopted Bavaria) and Meise in Belgium, to name just three. The climate of the rocky north coast of Brittany allows many of the succulents in Roscoff's Jardin Exotique et Botanique to flourish in the open, while Kristiansand's Naturmuseum claims the largest collection of cacti in Norway (all kept under glass, needless to say). Plain acquisitiveness has also provided a wonderful legacy: the 'Old Lady of Schönbrunn' (see page 18) is just one of the attractions of Vienna's Desert House, and the world-class Sukkulenten-Sammlung is a marvellous surprise in central Zürich.

Around the Mediterranean, the climate is more conducive to outdoor displays. Enthusiasts flock to the tiny hilltop village of Èze on France's Côte d'Azur and the nearby Jardin Exotique de Monaco. The beautifully sited Giardini Ravino, created only this century on the Italian island of Ischia, have one of the largest succulent collections in Europe, and in Puglia, Italy's 'heel', La Cutura has another really impressive collection of some very large specimens in and around its modernistic glasshouses.

Cactus gardens abound in Spain, where the first cacti arrived in Europe. At the Jardín Botánico Pinya de Rosa on the Costa Brava look out for plants named after its founder, Dr Riviere, such as *Opuntia rivieriana*. Further south, Cactus Nijar is appropriately located in Almería, which stood in for the Wild West in so many spaghetti westerns. Desert City, an unexpected oasis in a bleak northern suburb of Madrid, is a stylish

garden-cum-nursery-cum-research facility, while in complete contrast the black volcanic soil of Lanzarote is the perfect setting for one of Europe's great succulent gardens: Jardín de Cactus. Across the Mediterranean, Yves Saint-Laurent's much-visited Jardin Majorelle in Marrakesh has been joined by a newer attraction, Cactus Thiemann, on the outskirts of town.

While introduced species of cacti and garden escapes are an ongoing problem in Australia (see page 11), there are also great succulents 'in captivity' in botanical gardens from Sydney and Melbourne to Perth and Kimberley, the native habitat of Australia's own caudiciform, the boab (see page 2). Cactus Country, with its extensive collection, is a popular destination in Victoria.

Timing can be everything. The brilliantly coloured *vygies* (mesembryanthemums and relatives) that carpet the land after the spring rains across southern Africa are a seasonal highlight of Kirstenbosch, the Karoo and other reserves. Some flowerings are such rare occurrences that they hit the headlines, as the brief blooming of a Brazilian moonflower (*Selenicereus wittii*) at Cambridge University Botanic Garden did in 2021. And every summer since 1926 the Swedish town of Norrköping has planted a precisely executed 'cactus picture' in the town centre. Improbably far north for cacti outdoors, but a testament to their enduring attraction all over the world.

Further reading

ON CACTI & OTHER SUCCULENTS

Anderson, Edward F., *The Cactus Family*, Timber Press, Portland OR, 2001.

Anderson, Miles, *The Complete Guide to Growing Cacti & Succulents*, Lorenz Books, London, 2003.

Hewitt, Terry, *Cacti: An Illustrated Guide to Varieties, Cultivation and Care*, Southwater, London, 2013.

Kapitany, Attila, *Australian Succulent Plants*, Kapitany Concepts, 2007.

Rowley, Gordon, *A History of Succulent Plants*, Strawberry Press, Mill Valley CA, 1997.

Test, Edward McLean, *Sacred Seeds: New World Plants in Early Modern English Literature*, University of Nebraska Press, Lincoln NE, 2019.

Torre, Dan, *Cactus*, Reaktion Books, London, 2017.

The *CactusWorld* eLibrary of the British Cactus and Succulent Society provides access to a world-ranging collection of books, articles and essays on all aspects of succulents, from growing tips to biochemical research and a seventeenth-century duchess's watercolours: www.society.bcss.org.uk/web/downloads/Index%20CW%20eLibrary.pdf.

ON BOTANICAL ILLUSTRATION

Blunt, Wilfrid, and William T. Stearn, *The Art of Botanical Illustration*, Antique Collectors' Club, 2015. Originally published in 1950, this is still the 'bible' on botanical illustration.

Calmann, Gerta, *Ehret: Flower Painter Extraordinary*, Phaidon, London, 1977.

de Bray, Lys, *The Art of Botanical Illustration: A History of Classic Illustrators and Their Achievements*, Quantum, London, 2006.

Nickelsen, Kärin, *Draughtsmen, Botanists and Nature: The Construction of Eighteenth-Century Botanical Illustrations*, Springer, Berlin, 2006.

Rudolph, Richard C., 'Illustrations from Weinmann's *Phytanthoza iconographia* in Iwasaki's *Honzō zufu*', *Huntia*, vol. 2, 1965, pp. 1–28. Available at: www.huntbotanical.org/admin/uploads/02hibd-huntia-2-pp1-28.pdf. In his classic book of Japanese botany, in which he illustrates and describes some 2,000 plants, Iwasaki Tsunemasa acknowledged using the Dutch edition of the *Phytanthoza Iconographia* as reference for many of the non-native plants to which he did not have direct access. The first part of *Honzō Zufu* appeared *c.*1830, but the 93 volumes were not published in their entirety until 1921.

Stijnman, Ad, and Elizabeth Savage (eds), *Printing Colour 1400–1700*, Brill, Leiden, 2017, esp. ch. 18 (Simon Turner).

For more on the history of the title of the *Phytanthoza Iconographia* (a term coined by J.W. Weinmann), see John L. Heller, 'Linnaeus on Sumptuous Books', *Taxon*, vol. 25, no. 1 (February 1976), pp. 33–52, esp. p. 48.

MISCELLANY

Greenfield, Amy Butler, *A Perfect Red: Empire, Espionage, and the Quest for the Color of Desire*, HarperCollins, New York, 2005; and 'The Bug that Had the World Seeing Red', smarthistory.org/cochineal.

Crop Ecology, Cultivation and Uses of Cactus Pear: CAM Crops for a Hotter and Drier World, FAO/International Center for Agricultural Research in the Dry Areas, Rome, 2017: www.fao.org/3/i7012e/i7012e.pdf.

Encyclopedias of Living Forms, www.llifle.com/Encyclopedia/succulents.

World of Succulents, worldofsucculents.com.

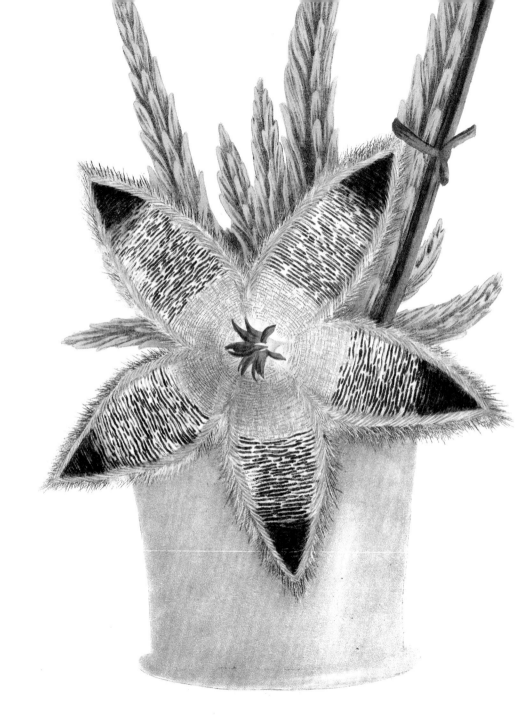

Picture credits

The Bodleian Library owns two copies of the *Phytanthoza Iconographia*. One is a four-volume edition (Vet. D4 b.5–8); the other is bound into eight volumes, four of text and four of plates (Arch.Nat. hist. G5–12). Both are folio editions. The plates reproduced in this book and listed below are taken from the latter edition.

Plate 42; *Plate* 43; *Plate* 44; *Plate* 45; *Plate* 46; *Plate* 47; *Plate* 48; *Plate* 49; *Plate* 50; *Plate* 51; *Plate* 52; *Plate* 53; *Plate* 54; *Plate* 55; *Plate* 56; *Plate* 57; *Plate* 58; *Plate* 59; *Plate* 60; *Plate* 61; *Plate* 62; *Plate* 63; *Plate* 64; *Plate* 65; *Plate* 66; *Plate* 67; *Plate* 68; *Plate* 69; *Plate* 70; *Plate* 71; *Plate* 72; *Plate* 73; *Plate* 74; *Plate* 75; *Plate* 155; *Plate* 156; *Plate* 157; *Plate* 276; *Plate* 303; *Plate* 354; *Plate* 355; *Plate* 356; *Plate* 357; *Plate* 358; *Plate* 433; *Plate* 434; *Plate* 435; *Plate* 474; *Plate* 487; *Plate* 488; *Plate* 489; *Plate* 490; *Plate* 491; *Plate* 492; *Plate* 493; *Plate* 494; *Plate* 497; *Plate* 498; *Plate* 505; *Plate* 506; *Plate* 507; *Plate* 508; *Plate* 562; *Plate* 616; *Plate* 765; *Plate* 766; *Plate* 828; *Plate* 911; *Plate* 912; *Plate* 913; *Plate* 914; *Plate* 1022; *Plate* 1023; *Plate* 1024

© Bodleian Library, University of Oxford, MS. Laud 678, p. 16 (9) (p. 9)
© Bodleian Library, University of Oxford: *Phytanthoza Iconographia*, Arch.Nat. hist. G 5 (p. 4)
© Bodleian Library, University of Oxford: *Phytanthoza Iconographia*, Arch.Nat. hist. G 7 (p. 29)
© Bodleian Library, University of Oxford: *Phytanthoza Iconographia*, Arch.Nat. hist. G 9 (pp. 19, 26)

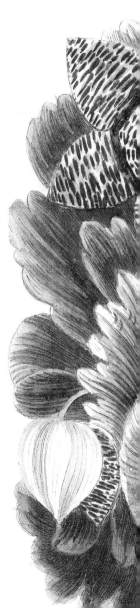

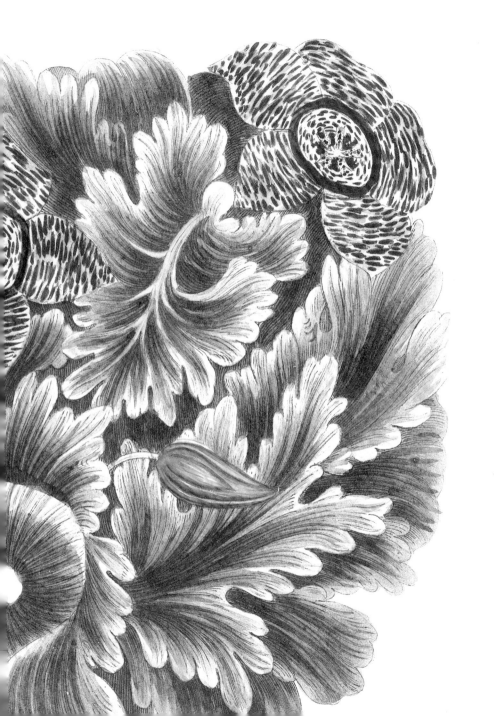

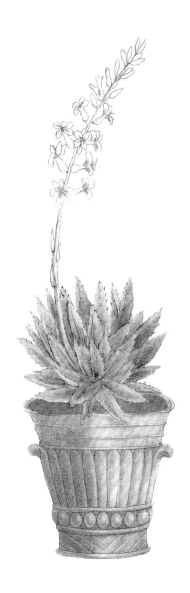